DIGITAL FANTASY PAINTING

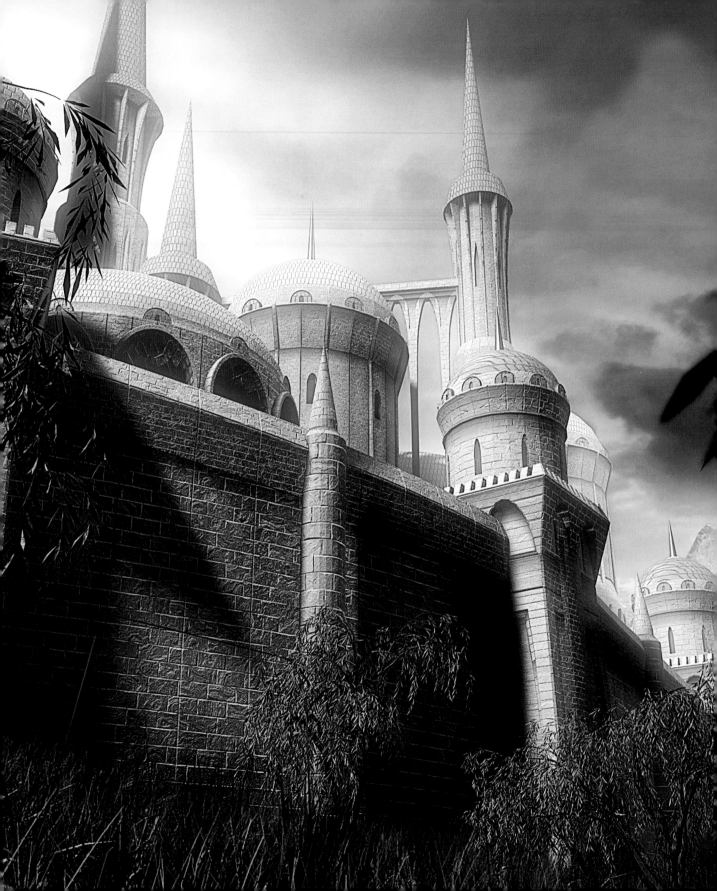

DIGITAL FANTASY PAINTING

MICHAEL BURNS

Watson-Guptill
Publications
New York

First published in the United States in 2002 by
Watson-Guptill Publications,
a division of VNU Business Media, Inc.
770 Broadway, New York, NY 10003

This book was conceived, designed, and produced by:
The Ilex Press Limited
Cambridge
England

Art Director: Alastair Campbell
Editorial Director: Steve Luck
Design Manager: Tony Seddon
Designer: Alistair Plumb
Project Editor: Jane Edmonds

Library of Congress Cataloging-in-Publication data

Burns, Michael, 1968-
 Digital fantasy painting / by Michael Burns.
 p. cm.
Includes index.
 ISBN 0-8230-1574-2
 1. Computer graphics. 2. Three-dimensional display
 systems. 3. Digital art. 4. Fantasy in art. I. Title.

 T385 .B8643 2002
 760--dc21
 2002009305

ISBN 0-8230-1574-2

Printed and bound in China

For further information on digital fantasy
painting and a list of useful websites, visit:
www.digital-fantasy-painting.com

Image on previous page by Dmitry Savinoff

contents

Introduction 6

section one

tools of the trade 8
hardware 10
commercial free objects 12
professional image editing 14
photoshop 18
alternative image editors 24
3D graphics software 26
poser 28
zbrush 30
bryce 32
vue d'esprit 34
lightwave 3D cinema 4D 36
3ds max 38
maya 40
plug-ins and filters 42

section two

components & ingredients 44
shaders and textures 46
creating realistic skin in 3D 48
creating textures 50
realistic flesh and skin in 2D 52
modeling heads and faces 54
creating hair 56
lighting fantasy scenes 58
inorganic objects: torpedoes 62
organic objects: leaves 64
organic objects: a branch 66
fantasy people: superheroes 68
fantasy creatures: the undead 70

fantasy creatures: demons 74
fantasy creatures: monsters 76
fantasy creatures: dragons 78
visions of the future: robots 82
visions of the future: spacecraft 84

section three

environments of the imagination 86
creating landscapes in bryce 88
creating landscapes in lightwave 92
water, terrain, and skies 94
water effects 96
painting the sky 98
landscapes of the future 100

section four

bringing it all in 102
alien worlds 104
the teahouse 108
the summoner 112
the album cover 114
creating fantasy maps 116

the gallery 118

Glossary 152

Software review 156

Index 158

Acknowledgments 160

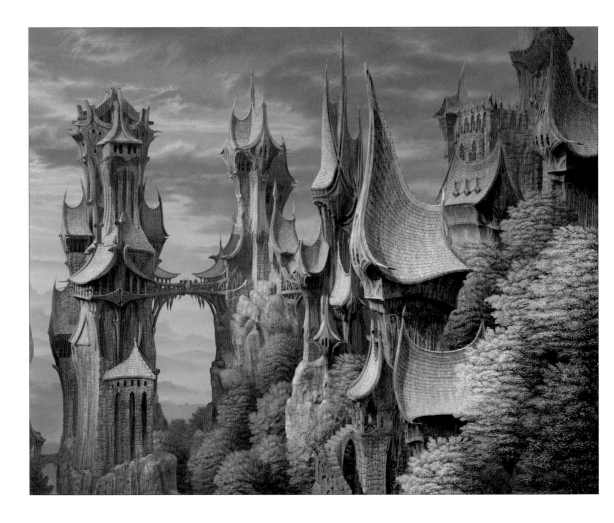

This is a book about visualizing the fantastic, a guide to the work of artists who create incredible worlds of the imagination or cross the boundaries of space and time using their skill and talents with computer software. You can follow in the footsteps of the experts by reading the step-by-step commentaries and tips contained in the following pages. But first we are going to take a look at some of the influences that have led up to the current wealth and variety of digital fantasy painting.

Ever since prehistoric times, people have been telling stories, using their imaginations to fill in the gaps in their knowledge of the world around them. Thus the sun and moon were chariots drawn across the sky by astral horses, lightning was perceived as the spears of angry gods, mountains were the

dwelling places of fearsome giants who controlled the weather, and earthquakes were the stirrings of great dragons in their lakes of fire deep underground.

Religions and faiths sprang out of these beliefs about a supernatural world, and people also began to amuse themselves and learn from myths and legends passed from land to land. In these folk tales, angels and kindly spirits guided mortals along the path of virtue, while demons and devils lurked in the darkness and shadows to reward those who strayed into wickedness. Every lake had a monster to drown the unwary, every hill held a sleeping king with a magic sword and every castle or great house, it seemed, possessed a ghost to terrorize the living.

Writers in the past two centuries thus had a great wealth of material to draw upon to create their fictional worlds of fantasy. Up to the present day, writers such as J.R.R. Tolkien, Robert E. Howard, Michael Moorcock, and many others have drawn on the rich vein of our storytelling heritage, while still others continue and expand the tradition to encompass other worlds and futuristic technology in the realms of science fiction.

In a similar fashion, artists have found inspiration from first legend and mythology, then more recently from works of fiction. The Greeks decorated their world with nymphs, centaurs, and other creatures of myth, and much later the pre-Raphaelite group of painters drew on this golden age for many of their symbolic and allegorical masterpieces. Children's books were illustrated by the likes of Arthur Rackham, whose fairy paintings and weird goblin characters continue to inspire the artists of today. In more recent times, the development of new art techniques saw a new generation of fantasy artists arise in tune with a massive resurgence of fantastic and futuristic fiction. Artwork from Roger Dean, Chris Achilleos, Bruce Pennington, Peter Jones, Angus McKie, Alan Lee, Chris Foss, and Tim White, to name but a few, adorned book jackets, record sleeves, and bedroom walls everywhere.

Now there is a new element. Born out of the advances of computer graphics and fired up by the visual imagery of films such as *Star Wars*, *The Matrix*, and *Blade Runner*, and computer games such as *Final Fantasy*, a new generation of artists have taken up the standard of digital fantasy art. They have at their fingertips a dazzling array of technology for creating anything from the smallest spot of rust on a robot to an entire landscape of a dreamt-up world. It is available at all levels of complexity to suit almost all abilities—not just those of an art college graduate with a degree in computer science. You, too, can create your own worlds of the imagination.

Above
Balazs-Ward-Kiss created this test render of a dragon's head in the early stages of the modeling process for a painting entitled *When Dragons Fly* (see page 78).

Opposite
Steffen Sommer was inspired by Tolkien's *The Lord of the Rings* to create this image, entitled *Rivendell*, with discreet 3ds max.

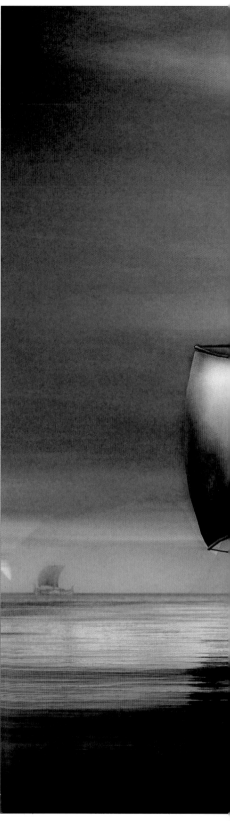

Modern fantasy artists have a wealth of digital tools at their disposal—with software colors and mouse taking the place of palette and brush. In this section we will be looking at the wide range of available tools. In the case of particularly prevalent software packages, their features and use in the process of creating fantasy art are discussed in some detail. For other packages there is an overview that includes an annotated image. The annotations take the form of tips on the best way to use the application and general advice on creating fantasy art. It is of course impossible to cover the entire dazzling array of software tools that are commercially available, so only a comparatively small number of packages are given this treatment. The "best of the rest" are outlined in the *Software Review* section on page 156.

The goal of this section is not to advocate the use of one piece of software over another, but to give the budding artist a taste of what is available and show how various tools can be used most effectively. After all, a tool is only as good as the artist who wields it, and no amount of technology can make up for skill and practice.

section one
tools of the trade

artist Dmitry Savinoff **title** heroes leave

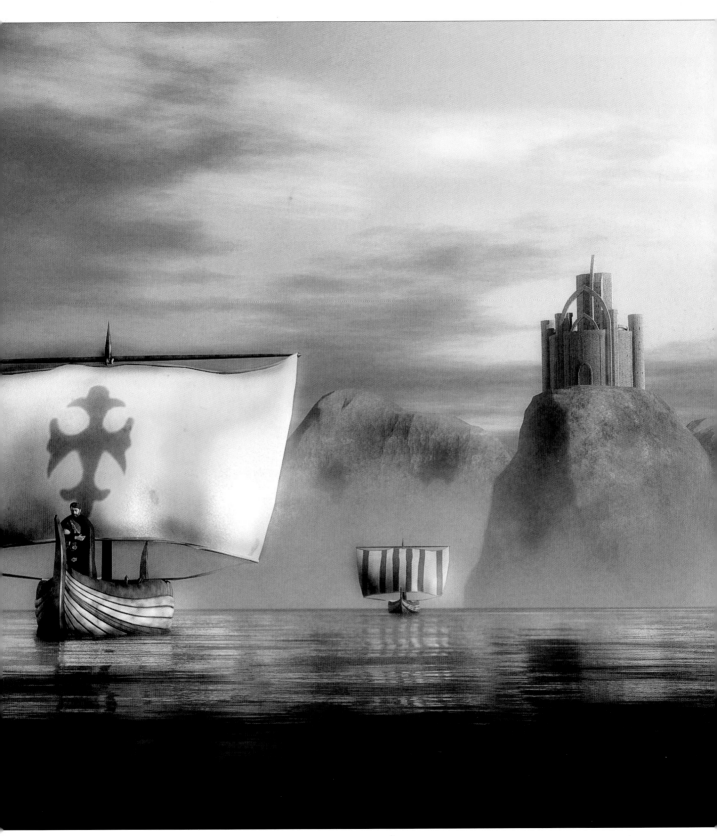

For the digital artist there are many choices regarding hardware as well as software. First, of course, there is the question of platform (the type of machine you work on) and the seemingly interminable Mac versus PC debate. Both Apple's Macintosh and the scores of Microsoft Windows-compatible PC clones have their evangelists, and with good reason.

In addition, there are, for example, Silicon Graphics' Irix systems and Sun Microsystems' Sun Workstation line, both of which are commonplace in the high-end graphics and animation industries. However, prices are generally prohibitive and the reasons for moving up to this level are fast disappearing. Advances in processor power, larger storage capacity, streamlined data transmission, and superfast system architecture have all contributed to producing workhorses of startling power on the desktop. With multiprocessing capabilities now available to all platforms, the question of which to use comes down to the one the user feels most comfortable with, or can afford. For memory requirements, 128MB of RAM should be considered the minimum for 3D work.

Operating systems

Microsoft's dominance of the market means that the majority of graphics software is available for Windows users, sometimes exclusively. For a long time, many of the higher-end 3D applications were only to be found on Windows NT or Windows 2000. Now Microsoft has launched Windows XP as its flagship, combining the stability and power of NT with the usability of Windows 98/ME. With professional and home versions of its new OS available, and most applications already compatible or making the move to XP, Microsoft is sure to retain its hegemony.

Apple's latest generation system, Mac OS X, is an advanced UNIX-based system that lays great store by its stability, power, and ease of use. It has a protected memory system and advanced multitasking capabilities, which leads to fewer system crashes, as well as support for multiprocessor systems. With an advanced graphics engine under the hood, Mac OS X has been successful in attracting complex image creation tools across from other platforms, notably Maya from AliaslWavefront and Vue d'Esprit from e-on Software.

Linux, an older UNIX-based system, also has its adherents in the high-end graphics scene. It has the unique advantage in that its source code is freely available, but some commercial examples of the OS have been developed, with added sophistication and the ability to be run on top of Mac and Windows systems. All will run the many graphics applications developed for the platform.

Graphics cards and peripherals

Graphics technology has also advanced incredibly in recent years. It is now common for graphics accelerator cards to carry 64 MB of their own video RAM and to be loaded with number crunching algorithms, which have the sole purpose of calculating geometrical equations and pixel values, thus removing the strain on the machine's main processor.

Several names are prominent in this field, including nVidia, ATI, Elsa, and 3Dlabs. The one thing to look out for, especially for 3D work, is that the card supports the OpenGL standard. Good cards are not cheap though, so high-end OpenGL is largely an option for serious 3D artists. Many workstations, however, ship with decent graphics accelerators as part of the package, thanks to the popularity of high-quality computer games. As long as the card supports a resolution of 1280 x1024 pixels, it will be adequate for most applications.

The host of available peripherals include the following:

Monitors For any graphics work, a good monitor is essential. The lowest specification should be a 17-inch screen, but 3D work is best carried out on monitors with larger screen sizes, such as 21-inch or more.

Mice Not just a pointing and clicking device, the humble mouse is often the paintbrush of the digital artist. A three-button mouse, often equipped with a thumbwheel, is a standard accessory for any serious 3D work.

Tablets Pressure sensitive drawing tablets are highly useful, with those by Wacom being the market leader. Many applications, such as Corel Painter, Adobe Photoshop, and AliaslWavefront Maya, can take advantage of the tablet's ability to measure pressure and react accordingly, increasing the flow of paint to a brush head or varying the thickness of a line in response to the amount of pressure of the pen on the tablet.

Scanners Flatbed scanners are incredibly cheap now compared with what they were a few years ago, and technical performance has increased considerably. Ideal for bringing in natural objects and photographs as texture maps or the basis of a scene, scanners are also very often used to import rough pencil sketches of a scene before the digital process begins, providing both a base and guide for the artist to work from.

Other items Printers for output, and external storage solutions for extra space, are also very handy components of the modern digital artist's toolkit. A modem or similar way of getting on the Internet is essential for downloading software updates, learning techniques, and letting the world see your fantastic creations.

The Internet is a treasure trove for artists. There are many resources to be found, both free and commercial, that will speed up the creation of artwork. Backgrounds can be made from the millions of photographs and illustrations available on the numerous royalty-free photo libraries. Many of these charge a fee for images but there are a lot of free resources, such as the NASA site (**www.nasa.gov/gallery/photo/**), which offer the chance to include photorealistic material in your work for only the price of an acknowledgement.

Textures and materials for use in 3D applications are widely available—it's possible to download for free or buy texture maps for any conceivable surface and appearance. Dosch Design (**www.doschdesign.com**) is just one of many companies that offer collections of textures for sale. The collections, which are available on CD, include human, animal, and creature eyes, skin, stone and concrete, metal and rust, and all can be used to render surfaces with a very realistic appearance and look. The high-resolution, multilayer textures include all relevant shader maps for the material properties, such as the color map, bump map, reflection map, specularity map, and diffusion map.

3D models and meshes of all descriptions are also available on the Web and from software companies where you can buy anything from plants to people. A good example of companies providing the latter is Daz Productions (**www.daz3d.com**). It offers figure models that have been created using digitized and photographic references from live models and are intended for use in Poser by Curious Labs. Its "Victoria" and "Michael" figures are made up of over 28,000 and 32,447 polygons respectively, with over 90 morph targets (parameters to reshape objects) in the heads to allow facial changes to account for mood, ethnicity, and character. Photorealistic texture maps are available for the figures, as are clothing and equipment sets. A comprehensive list of websites providing free 3D objects, textures, and other materials can be found at Ultimate 3D Links (for information log on to **www.digital-fantasy-painting.com**). Most of the commercial sites and companies offer their products on a royalty-free basis—that is, once you've bought the file or collection, you are then able to use it wherever and whenever you want.

adobe **photoshop,** curious labs **poser,** images from royalty-free sources

artist jason kendall **title** alpha 26

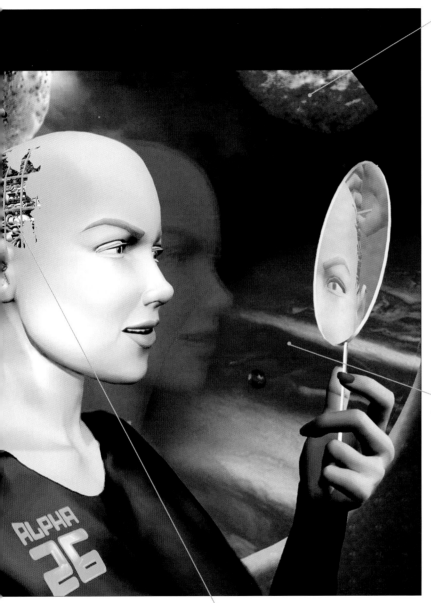

Fiery world
This NASA image of a moon is made more visually interesting by adjusting color, brightness/contrast, and hue/saturation commands until a volcanic look is achieved. Sometimes, just a few basic adjustments of this sort can really make a radical change to the appearance of an image.

Planets
This royalty-free image of Jupiter and its moon Io is on the NASA Hubble Space Telescope website. The original is in black and white. To turn it into a color image, you can drag and drop it into a new color document created in Photoshop. Create duplicate layers and use the color-adjusted options to color these layers in combination with brightness/contrast adjustments. Finally, reduce the opacity of the colored layers in order to blend them together and provide a greater degree of control over the final appearance. Dragging the opacity fader up and down until the desired subtle effect is obtained is a much quicker method than trying, undoing, and retrying menu commands or filters.

Cyborg brain
You can create this complex "brain" structure in two stages in Photoshop. First, crop a small section of a royalty-free image of an engine. Then create duplicate layers, and cut, paste, adjust, and move them around to build up a collage that will become the image. Creating an image in this way gives you a lot of freedom to experiment until you have achieved the result you want. The next step is to create a composite layer, with lighting effects, color adjustments, and detailing added on duplicate layers for greater control.

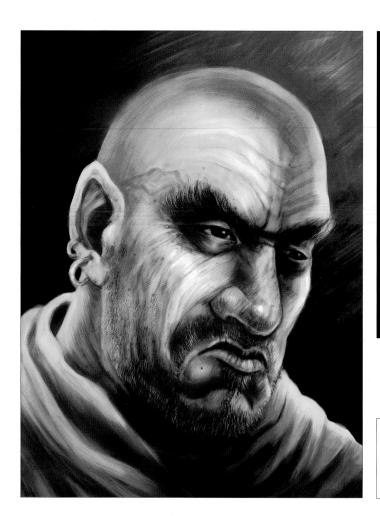

corel painter

artist michael yazijian **title** rogue warrior

professional image editing

tools of the trade

The amount of high-quality 2D software available to the professional digital artist today is phenomenal, but the field can be broken down into three areas: illustration, painting, and image editing.

Illustration packages

Professional illustration packages such, as Adobe Illustrator, CorelDraw, Deneba Canvas, and Macromedia Freehand, contain supplementary features designed to satisfy demands of Web designers and page layout artists, but all offer ways of creating advanced vector graphics. Common to all are tools such as paintbrush, pencil, pen, and various lines and shapes, and each has its own strengths and weaknesses. Illustrator's Paintbox, for example, contains a color pallet, a swatches pallet, a stroke pallet, and a gradient tool for creating an immense variety of advanced effects.

Painting with these packages takes in everything from creating and manipulating the shape of lines and curves to applying paint attributes,

14

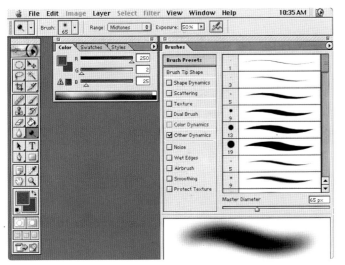

such as stroke fills and gradients, to objects. However, this type of software is seldom an artist's first choice for creating fantasy art, unless the intention is to create an image in a cartoon or comic book style.

Painting applications

Far more prevalent are 2D painting applications, such as Corel Painter, which work with bitmap images as opposed to the vector graphics of illustration software. All have tools for working with photorealistic images, brushlike effects, and fine shading. Common elements are an airbrush, pencil tool, paint bucket for fills, and tools to simulate natural media such as chalk, ink, or watercolor. Widely used by artists, they simulate traditional painting methods in the digital realm.

By far the most popular graphics software available to digital artists is the image-processing packages such as Adobe Photoshop and Corel PhotoPaint. These have become highly sophisticated, offering elements inspired by illustration and painting applications in addition to the image-editing tools they originally shipped with. They operate for the most part as layer-based applications, with users editing, adjusting, and adding color and other elements to images in a series of layers. They are mostly used in conjunction with photographic material, but their powerful features also mean that some artists choose to work with image processors as their only tool to create digital art.

Most of these applications are available in demo form for download from the websites of application developers. In the following pages we'll focus on some of the more popular 2D applications that are being used by digital fantasy artists.

Above left
Photoshop is one of the most prevalent tools in digital fantasy painting. Part of its appeal is the ability to create and save custom brushes in conjunction with a powerful paint engine. You can adjust dozens of different brush settings—including size, shape, tilt, spacing, scatter, and jitter—to get precisely the effect you want.

Above right
Adobe Illustrator is a powerful graphics package that handles vector graphics, basically artwork made of lines and curves defined by mathematical objects called vectors. Vector graphics are resolution-independent, and Illustrator has many tools to manipulate them. These include pens, brushes, and selection tools. Illustrator also shares many of the features of Photoshop, such as layers, color management, and filters.

Corel Painter is a "natural media" painting tool. This means that its toolset is intended to replicate as closely as possible the look and "feel" of natural media, such as watercolor paints, oils, inks, and pastels. You can add texture and color using palette knives, a large variety of brushes, pens, and dry media—such as artist chalk, oil pastel, and charcoal—and custom-built tools. You can also choose from a wide assortment of patterns and paper textures, clone tools, fonts, and gradients.

Special tools

Since early versions, Painter has also featured a tool called *Image Hose*, which is a special way to create custom brushes. Using this feature, any graphic can be saved as a *Brush* or *Nozzle* and sprayed (or hosed) over the parts of an image like any other brush. In this way, for example, banks of foliage can be quickly and easily created from a single leafy graphic saved as a *Nozzle*. Nozzle creation has become a spin-off industry in itself, and there are many commercial and freeware sites on the Web offering a huge variety of textures and organic forms.

The latest editions of Painter, now under Corel's procreate branding, have added a new advanced watercolor technology that recreates the behavior of pigments in water and allows "wet paint" to be manipulated before it dries. In addition, a tool called *Liquid Ink* replicates a brush covered in viscous, gloopy ink. Painter now also includes perspective grids, which are a non-printing array of lines that converge at a single vanishing point to help users create three-dimensional images.

Benefits of Painter

With Painter, the artist can create realistic paint effects and at the same time have the ability to undo changes, cut and paste other artwork, and use both natural and unnatural colors and textures.

Painter has advanced import and export options and can be used in conjunction with Adobe Photoshop or Corel Bryce, or as part of a wider graphics workflow. It is available for Mac and Windows platforms and more information can be found at http://www.corel.com.

Atlantis Calling

This image was created primarily in Painter because of its versatility of texture and handling of multiple media. Adobe Photoshop was also used at several points, primarily for handling layers.

Sunbeams
You can do the beams of light in reverse. Once you have the texture of the water to your liking, use a slightly darker blue watercolor tool to draw long lines and darken the areas between sunbeams.

School of fish
To minimize duplicate work and get some uniformity, paint one fish (or any other feature you wish to repeat in your painting), then copy and paste it several times, rotating the angle each time and overlapping where necessary. You can then go back over each fish and alter details, such as the size and shape of the spots and facial stripes, and add shadows where appropriate to make them mesh with the scene.

Water

To capture the look of light shining through the surface of the water, try painting in the background with a flat blue, layered with paler streaks, using the *Watercolor* tools and round *Camelhair* brushes. Next use rough-edged brushes, like *Dry Ink*, *Loaded Oils*, and *Grainy Airbrush*, to lay down grainy patches of color to resemble disturbed bubbles in the water, and run a *Spatter* watercolor brush over the finished product to quiet it all down.

Rocks

One way of getting the rough grain of the rocks is to first paint them with *Loaded Oils* (in this image, dark greenish-black) and a loaded *Palette Knife*. Then go back over the top with *Dry Ink*, *Rough Chalk*, and other grainy tools in a variety of colors to pick up the coarse texture of the background paper.

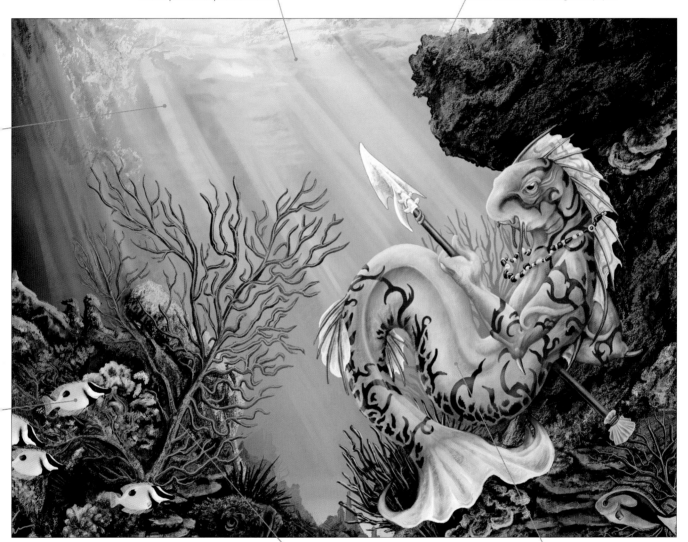

Coral

Coral can be painted in much the same manner as the rocks, with heavy use of the *Dry Ink* and *Loaded Oils* tools. Apply a dark background color and then pick out highlights using rough-textured tools and various interesting paper grains. You can use the *Seurat* artist tool to create a stippled effect. The large red coral can be done with *Loaded Oils* and *Dry Ink*, with watercolor added afterward to provide shadows.

Creature

The creature can be painted with *Camelhair* brush tools to give a smooth, slick look in contrast to the rocks. Add the striping with the round *Camelhair* brush.

corel **painter**

artist ursula vernon **title** atlantis calling

Almost every artist in this book has experience of Adobe Photoshop, and many of the featured artworks have seen the touch of this most prevalent of image-editing applications. From its early days as a kind of "digital darkroom" application, Photoshop has grown into a multifunctional studio, adding vector graphics manipulation and natural media tools to its pixel-pushing arsenal.

The Photoshop artist's palette consists of a variety of specialized tools. The selection tools, also known as *Marquee* tools, allow rectangular, elliptical, single row, and single column selections of the image, which can then be moved, cut, or cropped. In addition, the *Lasso* tools make freehand or polygonal (straight-edged) selections, while the *Magic Wand* tool selects areas with similar pixel values. There are also *Paint Bucket* and *Gradient Fill* tools for applying color to large areas, as well as *Blur*, *Sharpen*, *Smudge*, *Burn*, and *Dodge* tools. Built-in special effects, such as the ability to clone areas of the image onto each other, paint parts of the image as a pattern, manipulate color, and "heal" parts of the image, can all be accessed from the tool palette and are bolstered by a multitude of plug-in filters. Among other things, these offer artistic, texture, distortion, and lighting effects, including glows, spotlights, and the lens flare effect loved by spaceship artists everywhere.

Jhenna, Freelance Cop shows the power of Photoshop in the hands of an excellent fantasy artist.

Pipework
The pipes use the improved bevel, gradient, and pattern features in the latest version of Photoshop. Create the pipe shape, bevel it with a high, smooth bevel to achieve the curve of the pipe, put a gradient layer on *Multiply* for the light source, and find a nice blotchy pattern from the program's pattern library and overlay it lightly on the layer. As a final touch, add a drop shadow and some freehand work.

Flashlight
The flashlight spot is easily created in the *Layer Filters* palette. Make an oval, set the layer opacity to zero, apply an outer glow of a light fuzzy yellow, and an inner glow for the center with a brighter yellow.

Water
It can be time-consuming to achieve the desired result for water and you should appreciate how light refraction and reflections behave. Water that is more perpendicular to the viewer will be more transparent; water that is more parallel will reflect the environment.

adobe photoshop

artist kristen perry **title** jhenna, freelance cop

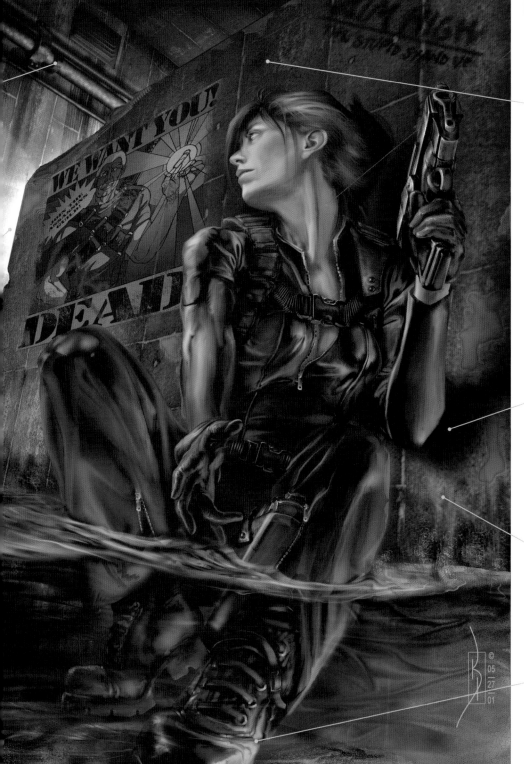

Shading

One of the big tips for shading is never to use white or black. In nature there are no such colors, only very close varieties. Use a colored or saturated tone of the base color for shadows and highlights, otherwise the white will make your highlight look chalky and the black will flatten your shadows.

Shadows

An easy way to make a good shadow is to create a new layer. Set to *Multiply* on top of the object layer. Then, holding the control key (Windows) or the command key (Macintosh), click in between the two layers to create an adjustment layer. This will make the new layer affect only the object layer. Then, take a saturated deeper color of the object and color the area for a shadow. Finish by reducing the *Opacity*.

Walls

For walls, a seamless concrete texture can be created, then patterned. Flatten the layer and use *Free Transform* to skew it into perspective. Next, illustrate details such as the seaweed and plaster chips shown here.

Reflective lighting

The blue reflective lighting from under the water can be built up with a paintbrush set to normal on a layer set to screen. By adding, smudging, and subtracting color gradually, it's possible to achieve a very flexible light source on a layer that can change colors at will, be stacked or layered for other effects, and lightened to the perfect shade.

I You can do initial sketches of detailed parts of the image and scan them in, then add all the background elements in Photoshop. Here you can see a really quick block-in of color over the initial sketches of the girl and the orc head, which is still visible.

2 The best part of using Photoshop is that you can keep each element of the picture on a separate layer so that major changes can be done without affecting the rest of the picture. Here, for example, it's easy to change the coloring of the woman's skin, as well as completely change the tree in the background.

3 The next step is to add further elements of the picture, such as the banner. After blocking in the shape of an object, lock the transparency of the layer you're working on. You then don't have to worry about painting over the edge and changing another part of the image.

photoshop
tools of the trade

A key strength of Photoshop is its use of layers, which broadly speaking is a way of working using a number of transparent sheets stacked on top of the main image. These allow you to work on one element of an image without disturbing the others. You can change the composition of an image by changing the order and attributes of layers. In addition, special features such as *Adjustment Layers*, *Fill Layers*, *Layer Blends*, and *Layer Styles* let you create sophisticated effects. Another way of working with images is to use selections, defining only the parts of images requiring change. In the same way that a traditional photographer uses masking tape, the area that is not selected can be "masked" or protected from editing. The use of masks to isolate and protect selections allows the artist to apply color, filters, and effects such as transparency to the image. Masks can also be saved as alpha channels (simple 8-bit grayscale images), which can then be reused for effects later in the same session, or exported to future projects.

Photoshop is ideal for illustrations because of its flexibility and ease of use. At any point during the creation of a picture you can resize, recolor, or relocate any part of the image. That's something you can't do easily with more traditional media such as oils or acrylics. Plus, there is no cleanup afterwards and no initial setup time. Photoshop also has many tools and filters to help you complete a picture. Always make sure you use only those that enhance the picture—don't add some effect just because it's there.

The main tools used in *Gladiator Girl* are *Paintbrush*, *Eraser*, and *Smudge*, plus a little of the *Dodge* and *Burn* tools. You can also use the *Path* tools to create smooth shapes like the hair. The main filters used here are *Blur* and *Motion Blur*. Liberal use is also made of the *Levels* and *Hue/Saturation* adjustments, usually applied as a separate layer so that you can go back and make changes if you want to. Another tip is to change freely the blending options of the layers while you're working to get different effects.

4 You can now make major lighting changes, clean up the edges, such as those of the woman's body, and refine details, such as the woman's arm, face, and hair. A quick tip is do the face separately at a larger size so that you can paint the details more easily, and then paste it back into the main image.

5 Keep going over each element of the picture, such as the tree, the orc's head, the armor, and so on, refining and adding detail as you go. It's important to keep the picture looking like a complete image, as opposed to the many separate images that it really is— this will help you view the composition as a whole. You can use the *Folder Sets* in Photoshop to help keep the major elements, such as the woman and her armor, grouped together.

To quickly add more detail and sharpness to an item, such as the tree, make a copy of the layer and apply the *Find Edges* filter, found under *Stylize*. Change the blending mode to either *Darken* or *Multiply*. Then it's a matter of experimenting with the *Opacity* and the *Levels*. By dragging the white triangle on the *Input Levels* to the left, you can get rid of the lights and mid-tones of the new layer so that you can bring added detail to the edges without losing the color of the layer underneath.

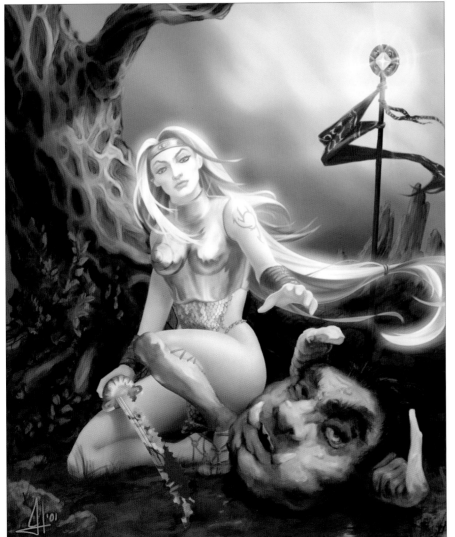

adobε

photoshop

artist james haywood
title gladiator girl

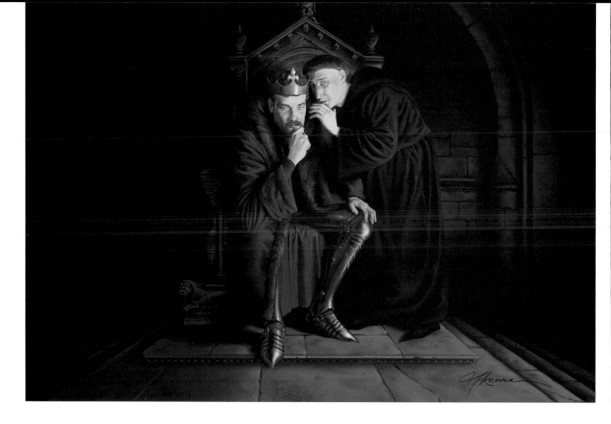

For painting, the Photoshop user has three main choices: the *Pencil*, the *Paintbrush*, and the *Airbrush*. All apply the chosen foreground color to the pixels of the image, with the behavior of the digital brush corresponding to its real-world counterpart. Pressure settings for the paint tools can be controlled by the use of a digital pen and pressure sensitive tablet, or you can build up color in one place by holding down the mouse button without dragging.

Options for painting and editing tools include a variety of blending modes, such as *Overlay*, *Darken*, *Lighten*, and *Luminosity*. These set the way in which the painting or editing tool affects the pixels in the image. Version 7.0 of Photoshop includes a painting engine that brings dry- and wet-brush effects, including fine art media such as pastels and charcoal, as well as the ability to add special patterns such as grass and leaves.

The aim of the artist of *The King* was to achieve a fairly non-digital traditional look. Everything was kept very simple, using only Photoshop's basic paint tools for that "hand-painted" look, with no use of photographic elements or filters at all, and no other adjustments made.

adobe photoshop

artist martin mckenna **title** the king

A very rough sketch done in pencil, and then scanned, provides a painting guide and a base to work on in Photoshop.

Within Photoshop, go straight to work on painting the faces of the characters, creating a separate layer for each element as you work on it—each face, hand, and so on. Slowly work up the facial details using Photoshop's basic painting and blending tools to create as much of a hand-painted look as possible.

Moving on to the king's cloak, block in the basic color, again on a separate layer. As with the skin tones, apply color using the *Airbrush*, and blend using the *Smudge* and *Blur* tools.

Having finished most of the details in the character's faces and some of their figures, start to fill in some of the area immediately surrounding them, beginning with the back of the throne. You can use an intermediate layer for this, between the sketch background and the other painted elements.

Now with the figures more or less complete, start to bring in some of the surrounding color. Building up the shadows helps create the mood for the scene.

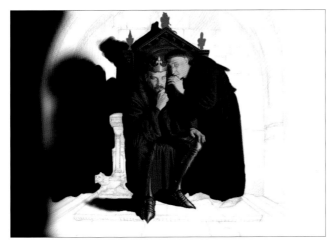

With the scene almost complete, start to build up the details of the background. You will be able to do this easily with the figures and throne being on separate layers. All that is left to do is to flatten the layers, and tie all the separate elements together using Photoshop's blending tools. Tweak the image slightly using *Brightness/Contrast* or *Curves* just to even out everything.

Photoshop is not the only image editor, though it is by far the most popular package used by fantasy artists. There are at least a dozen other well-featured software applications that you can use to push pixels, but only a few of the more noteworthy can be covered here.

The GIMP (Graphic/GNU Image Manipulation Program) is a freely distributed image editing application available on the Windows platform and Mac OS X (find it at **www.gimp.org** and **www.macgimp.org**). Often compared to Photoshop, it has many similar functions in common but it is much cheaper. The GIMP lacks CMYK support but is widely used by fantasy artists for manipulating RGB-based file formats such as JPEG and TIFF.

Deep Paint 3D by Right Hemisphere (**www.righthemisphere.com**) is a 3D texturing and painting tool that provides authentic artistic media—such as oils, watercolors, crayons, and pastels—which can be brushed directly onto 3D models. Available as stand alone software with a bi-directional interface to Photoshop, Deep Paint 3D also integrates with 3ds max, Maya, Softimage, and Lightwave 3D.

Satori PhotoXL (**www.satoripaint.com**) combines vector and editable object-based bitmap image processing in a single environment. It offers a wide range of freely scalable object-based 2D design tools, including natural media brush drawing, illustration, photo-retouching, 2D graphics, compositing, color correction, image processing (batch processing and macro), special effects, onion skinning, and interactive masking as well as rotoscoping features. It uses a "non-destructive" workflow, which Satori claims scores over the pixel-editing method of Photoshop and others.

As part of its Corel Graphics Suite on Mac and Windows platforms, Corel (**www.corel.com**) includes Corel PhotoPaint. This is a very close rival to Photoshop and the two applications share many similar features. PhotoPaint offers such tools as *Smart Blur,* which creates images with sharp edges and blurred contents and is ideal for skin tones, an *Interactive Drop Shadow* effect, a color channel mixer, and the ability to drag and drop masks between open image files. PhotoPaint also features an *Image Sprayer* tool that allows you to load in full-color bitmap images and simply spray them across the digital canvas. You can change the size, tiling, and order of the images in the spray sequence and in this way can create realistic or surreal pieces of artwork.

corel **photopaint**

artist jason juta **title** deep one

Lighting
Light and shadow are important elements and need careful attention. Create side lighting in a more subdued color to help to model forms in the image, such as the green light on the right-hand side of this painting.

Softening
It is very important to keep edges and textures fairly soft and rough to avoid the typically "cold" and artificial appearance of digital art. If you continuously resize picture elements and blend them together, you can keep an overall even quality.

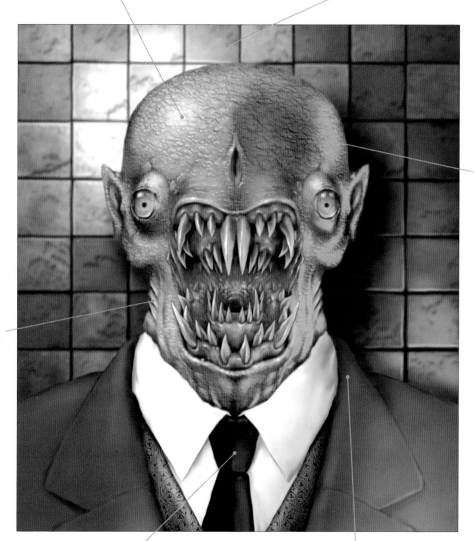

Textures
Texturing is added with sparing use of effects, or by overlaying and manipulating found textures. In this image the skin scale texture was "spherized" in places to give a more three-dimensional appearance, and highlights were added to increase the realism.

Layering
Layering is an important technique. Use transparent layers with *Subtract* and *Add* modes to apply shading. The main colors are kept on a layer over the scanned drawing, with the layer set to *Multiply* to keep the drawing visible.

Cloning
Cloning tools allow you to complicate and define skin scales and wall textures. Copying and flipping will help to create the required symmetry, which in this image is offset with lighting and details like the off-center necktie.

Blending
A helpful technique is periodically to blend the entire painting, which is important in making photographic elements fit in with digital elements. The customizable painting, smearing, and effects brushes in Corel Photo-Paint are indispensable for this.

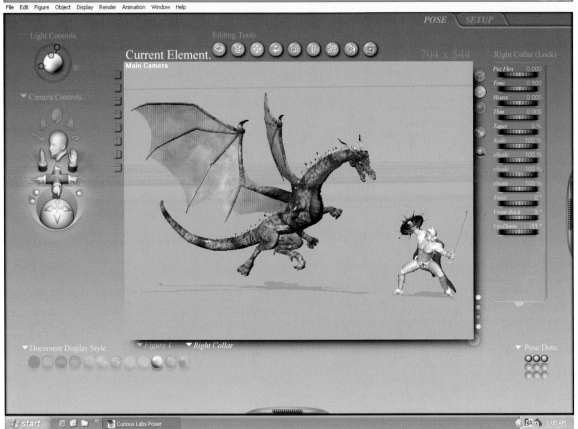

There is a vast array of software packages available with which to create fantasy artwork in 3D, but most share the same building blocks and perform the same basic functions: modeling, rendering, and animation. We are not dealing with animation in this book, but be aware that most multifunctional 3D software packages will offer some capacity for this subject area.

Modeling

Modeling can be seen as the creation, arrangement, and interaction of geometric models and planes, which together make up the skeleton or frame of a scene.

Models can be formed from primitive objects, such as spheres, cubes, and cylinders, which are combined together to create more complex shapes, or from 3D extrusions (or projections) and manipulation of simple line objects, such as curves and circles.

Modeling types or drawing modes vary, the most basic being those involving the use of polygons. These are constructed from line segments or edges, with three or more connected edges making up a face or shape. The coordinate points or vertices of the lines define and control the facets of the polygonal shapes. Then there are curves known as splines, which are defined by the position of start and end points as well as phantom points along the curve. More advanced are NURBS (non-rational uniform B-spline)

Left
Curious Labs Poser is an ideal introduction to 3D modeling. Its figure-creation tools are widely used in fantasy art, as in this example, the first stages of *Dragon Quest*, by Michael Loh. See page 60 for the finished work.

3D graphics software
tools of the trade

curves, which are defined by the position of control vertices (CVs) that pull the curve into a more fluid organic shape. These CVs do not lie on the curve itself, but "float" above the surface. Primitive objects can be created from either polygonal or NURBS geometry, and different tools are used to manipulate objects created by each method. Combining or editing primitives can create more complex objects.

When modeling objects using polygons, vertices in the polygonal "mesh" are directly pulled and manipulated. In NURBS modeling, the CVs create a cage around the object. Pulling on the CVs allows smooth deformation of the object. More processing power is needed when manipulating NURBS objects rather than those made up of polygons, due to the greater amount of mathematical calculation required.

Some higher-end packages also offer the facility to create objects with surfaces, which are built up from a refined polygonal mesh. Both NURBS and polygonal objects can be converted to subdivision surfaces when greater detail is required.

Rendering

Rendering can be defined as the application of textures and lighting, which together transform a mere collection of objects into a realistic scene. All the data in the 3D scene—the location and nature of all light sources, locations and shape of all geometry, and also the location and orientation of the camera through which that scene is viewed—are collected to create a 2D image.

On pages 46–53 the creation of textures and their application will be discussed and some examples shown of their use in digital painting. The use of lighting will be explored on pages 58–61.

Getting started

Although these terms and explanations may seem complex to the new user, most software applications take the pain out of the process, hiding the mathematics and leaving the artist free to create. The rule of thumb when venturing into 3D is the greater the amount of modeling options offered, the more complex (and usually more expensive) the software package. It is therefore wise to start with the most rudimentary 3D application you can find to learn the basics before moving into the high end.

One factor to remember—and it's one that some 2D artists have trouble with—is that when using any of these packages you must be able to "think" in 3D. You need to be aware that your canvas is based on the world around you, and the objects on it must be lit, shadowed, colored, and defined in a similar fashion, always with the knowledge that you have that extra third dimension—the Z-axis—to contend with.

It is hard to split modern 3D graphics applications into distinct groups and it would be impossible to cover the whole range. Consequently, on the following pages we will look at the packages most commonly used by practitioners of digital fantasy painting.

Poser 4 is a natural choice for the creation and rendering of the characters in an image such as *The Hawkriders*. The Poser render engine gives a softer feel than most other 3D packages at this level and is perfect for character-based images. The image is essentially in two pieces—a landscape image rendered in Vue D'Esprit and the characters created with Poser.

curious labs POSEr

e-on software vue d'esprit

artist ken gilliland **title** the hawkriders

1 You can create characters using DAZ 3D models and some custom-built textures. *The Hawkriders* started with the cooper's hawk. A quick 30-frame wing flap animation was created for the hawk, allowing the creation of a series of unique flight poses using the animation slider. The saddle, hood, and reins props were then added and parented to the hawk. (Parenting is where an object is linked to another—its child—in a modeling hierarchy: when the parent moves, the child moves with it.)

All items were then scaled up by 350% so that the raptor, one of the birds available from DAZ, would be large enough for the Hawkrider. Once the rider was created, posed, and had clothes added, it was parented to the hawk as well. Accessories, such as the quiver, bow, and hair, were then positioned to complete the character. Use of Poser's view cameras ensured that the character was properly seated on the saddle. You'll find that when panned back slightly, the hand and face cameras are often easier to manipulate than the main or auxiliary cameras (inset).

2 Once you have finalized a pose you are ready to create and add texture maps and give them a test render. Since Poser doesn't have a "Copy Character" feature, the rider and hawk in *The Hawkriders* was saved as a compound character. This character was then reloaded as an additional figure. The pose and textures were altered to add individuality to the new character. With several complex characters on screen, Poser begins to suffer from memory requirements. *Using a Document Display Style* such as *Outline* or *Flat Shaded* will speed up the program again.

3 A good tip is to render your image large to start with so you don't regret it later when someone wants it bigger. 3600 x 2400 pixels is a typically good rendering size. This, of course, requires much memory, disk space, and patience over an extremely long rendering time. With *The Hawkriders*, a 3600 x 2400 background was rendered in Vue D'Esprit and imported into the Poser image.

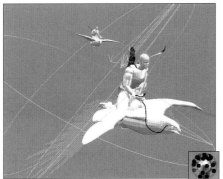

4 When doing the final render, choose *New Window* under *Render Options*, which allows larger renders such as the desired 3600 x 2400 image. Unfortunately, Poser takes the on-screen resolution of the background image, which in *The Hawkriders* was 800 x 600. This was expanded to 3600 x 2400, leaving an undesirable pixelated background. In order to solve this problem, the characters were rendered against a neutral color and masked into the background with a 2D-paint program.

5 Having the background in place will provide the lighting and camera angle references needed to make the Poser characters believable. Using Poser's freehand camera tool, it is easy to achieve the proper camera angle to match the background. With lighting, the brightest light in *The Hawkriders* was made to match the character using the *Lit Wireframe Document Display Style*.

6 One option for adding the final touch of realism to flight is to use *Motion Blur*. Poser Pro Pack (also from Curious Labs) has *Motion Blur* capabilities for animated and still renders, but it is too pronounced for the desired effects of *The Hawkriders*. The *Freeform* tool was used to select the wings and hood tassels of the hawks. Generally speaking, it's best to use just enough *Motion Blur* to remove the hard edges in most areas and save what will be noticeable for areas of rapid motion.

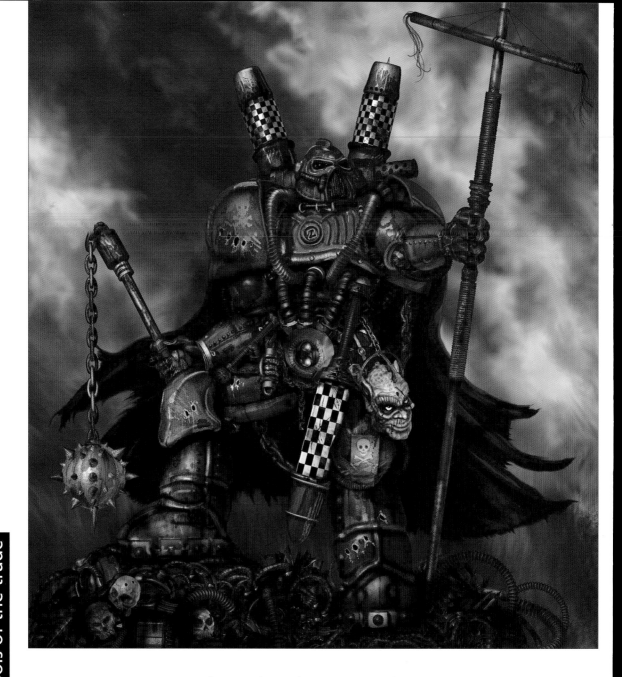

ZBrush is a package of real-time 3D sculpting, painting, texturing, and deformation tools in one integrated environment. It uses proprietary "smart pixels" called Pixols for precise image control and editing. ZBrush features sophisticated texture-mapping tools, extensive sculpting and deformation tools, environment mapping, shadow rendering, and a text-based scripting language called ZScript. This can be used to create integrated interactive tutorials and automate any ZBrush action, enabling ZScript-created buttons to execute many actions in a single click. A ZScript called *Texture Master* was used here to produce a perfectly mapped texture image.

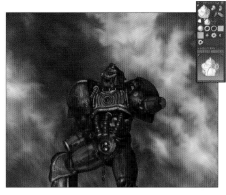

I Use a pencil sketch (scanned in and resized) for laying out an image to ensure proportion and composition are correct (there is nothing worse than detailing an area of an image only to find that it's in the wrong place or too big). In ZBrush, set the canvas size (this can be up to 4000 x 4000 pixels). Different elements of the image can be placed on multiple layers, as in the *Corrosive Marine* where five or six layers are used for the background, body, the armor, the foreground, and so on. Use a *3D Plane* to fill a background layer and then paint the sky effect onto it. This is just one of the ways in which ZBrush combines 2D and 3D features into one application.

To create the background canvas you can use the flat material and a range of the standard alpha brushes that come with the program. The process is just like using any standard 2D painting package; you simply paint onto a canvas until you achieve the desired result. To get the cloud effect, a few different colors can be used repeatedly over the same area, without any depth switched on (ZADD off). To blur the clouds use the *Smudge* tool, again with "Z" off, and smudge around the whole canvas. Finally use the *Shading Enhancer* brush to give some contrast.

2 To achieve the corroded metal effects, like those used in the *Corrosive Marine*, create a set of metallic procedural materials. ZBrush 1.23 has 66 native materials and from each of these you can create numerous others by altering the base settings: ambience, diffuse, reflectivity, specularity, noise, noise radius, color, bump, and so on. Dull and rough-looking materials can be used to simulate rusted patches and shiny, reflective materials can simulate areas of non-corroded metal.

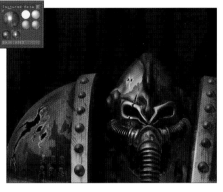

3 Begin modeling the body parts from basic spheres. Rather accurately, ZBrush has been likened to digital clay and it is possible to take a mesh sphere and simply push and pull it into the shape you require. In *Edit* mode (a freeform mode to allow you to apply deformations to a mesh) you can even paint depth straight onto your model. The marine's head, for example, started out as a sphere, with two holes indented for the eye sockets, and the eye ridges were built up by simply painting over the areas to be raised. By using a symmetry mode you can ensure that both sides of the model look the same and before long the mesh takes shape. Not a NURB in sight.

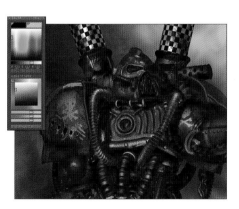

4 Fit the body parts together from their various layers and create a number of texture maps for the armor and weapons. The checkered portions can be created using the 2D toolset available in the ZBrush tool panel. It is possible to draw just about anything straight into the document window and grab it as a texture. There are *Smudge* tools, *Blur*, *Intensity* brushes, a *Clone* tool, *Red-Blue-Green Intensity* sliders, a *Hue and Contrast* setting, and so on—most of the tools found in a more conventional 2D-paint package in fact. Add to this the alpha brushes that you can create by simply grabbing the screen and it is possible to make any number of amazing textures.

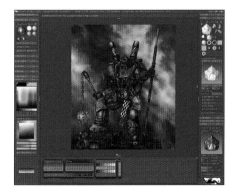

5 To complete the ZBrush image, set up lights and some environment settings. Add a couple of glow effects with differing light colors, and render the final image with heavy shadows. You can add finishing touches to the image by doing some post work in Photoshop, or you can use the *Smudge* and *Blur* tools in ZBrush for the final render.

pixologic zbrush

artist glen southern **title** corrosive marine

Corel Bryce is one of the stalwarts of fantasy art. Though primarily a tool for creating landscape scenes ranging from frog ponds to planet-scapes, with excellent environmental effects, it does contain some object modeling capabilities, especially in its most recent release. It has an intuitive interface that consists of a screen-filling *Working Window* where the objects in a scene are planned and positioned, *Tool Palettes* that dynamically update for each task, view and camera controls, and a preview window for viewing small rendered versions of the scene in progress. Bryce has powerful rendering tools and artists often bring objects and components created in other software into Bryce to render their scenes.

There are controls for creating skies, where the user can set the number, shape, and direction of clouds, sky color, light direction, and atmospheric effects. A *Terrain Editor* can be used to create custom terrains, and natural elements such as rocks and water can easily be added to create landscapes. The *Materials Lab* is a powerful tool to add realism to a scene, allowing the user to apply combinations of textures and channel values to simulate materials. The latest release adds more authentic and controllable lighting features, enhanced rendering, and a *Tree Lab*, enabling the creation of realistic tree objects in a scene. Bryce users can now also model using sphere-based Metaballs to create organic shapes in addition to the more traditional method of manipulating primitives. The software ships with a host of preset values and objects with which it is simple to create an advanced scene, but every aspect of Bryce is capable of being customized, allowing artists to create the most alien of worlds or the most realistic of environments.

Autumn Flirts with Winter by Martin Murphy is an example of the use of Bryce in combination with other programs, with the initial setup and render being done in Bryce.

The four figures represent the four seasons. Each season has the freedom to leave or wander around the platform while overlooking the earth below. The platform is where weather elements can be created, such as thunder (trumpeting horns) or lightning (a large glass dome which could flash light into the sky). At this moment in time, while Summer is hard at work, Spring is upset that her love, Autumn, is giving Winter a token of his affection.

Martin Murphy 1998

corel **bryce**

artist martin murphy **title** autumn flirts with winter

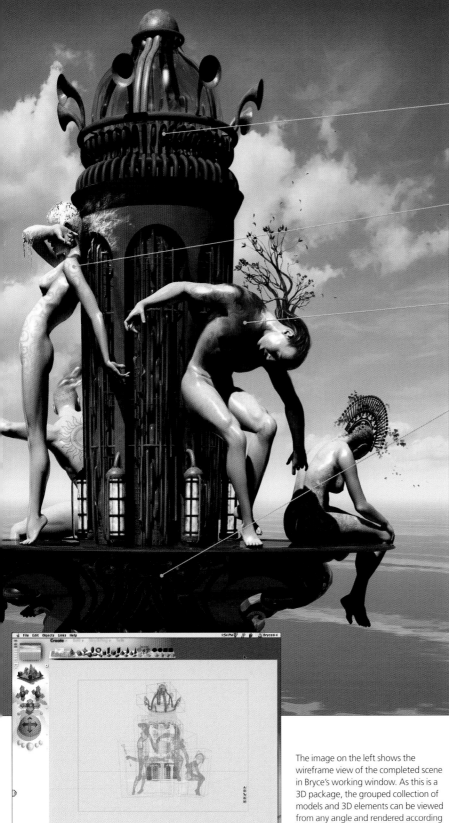

Organic shapes

The more organic shapes, such as the glass dome, horns, curved tubes, and large swirls underneath the platform, are modeled in Ray Dream Designer. These elements are imported, textured, and arranged separately in Bryce.

Details

Once all the 3D elements are in place, it's time for Bryce to do the final render. All the character details, such as hair, tattoos, body textures, fire and ice, are created in Painter, painting on the Bryce render.

Figures

The four figures are posed separately in Poser, then exported as OBJ files (the widely used Wavefront file format that carries geometrical information for figures). In Bryce they are imported and given a polished stone texture.

Platform

The platform, created in Bryce, uses mixtures of primitives for the main structure as well as for the components such as pipes and lanterns. Three terrain meshes are used for the large gold leaves at the bottom, employing an image map created in Photoshop. The clouds are added from a photograph.

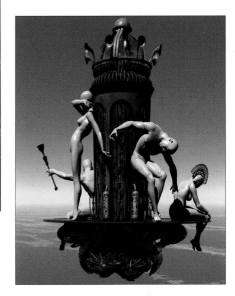

The image on the left shows the wireframe view of the completed scene in Bryce's working window. As this is a 3D package, the grouped collection of models and 3D elements can be viewed from any angle and rendered according to the artist's preference.

The image above is the final Bryce render before additional detail is added in Corel Painter.

Vue d'Esprit by e-on Software is a 3D scenery, animation, and rendering tool that is fast becoming very popular with fantasy artists. Previously only available on the PC platform, it has recently been ported to Mac OS X and takes advantage of technologies such as innate multi-threading and multiple processors for extra rendering power.

Vue uses a layer-based system to organize objects in the scene, set up in a movable list called the *World Browser*. Scenes are created and organized in a four-window view (*Top*, *Side*, *Front,* and *Main Camera* views). It supports ray tracing for rendering and has five preset render settings corresponding to different levels of detail.

Like other 3D applications, Vue contains integrated technologies and editors to perform specific tasks, such as *SolidGrowth*, a realistic tree and plant creation and rendering algorithm, which makes every plant and rock unique when dragged into a Vue scene. The *Solid 3D Terrain Editor* offers a complete set of advanced tools to model a terrain and can export it to a dozen 3D file formats along with its corresponding color and bump maps. A *Material Editor* is included, allowing the creation and editing of simple, mixed, and volumetric (applying to the whole volume of the object not just the surface) materials. The *Atmosphere Editor* allows users to work with Vue's volumetric atmosphere system. This calculates the interaction of light with particles suspended in an atmosphere to create haze and so on. Similarly, the application calculates internal lighting and density to create volumetric materials (smoke, dust) and volumetric clouds.

Some of Vue's other features include a *Light Editor* with a complete lens flare system with global/local settings, light shadows, gels, and volumetric lights (visible rays with optional suspended particles), as well as procedural mapping modes, support for caustics and the ability to print pictures from within the application.

Vue d'Esprit ships on 2 CDs along with hundreds of atmospheres, clouds, 3D objects, materials, textures, and over 50 example scenes.

Trees
The *SolidGrowth* algorithm can create trees that have a variety of colors in their leaves and bark textures. To create a more realistic scene, take pictures of real tree bark with a digital camera and apply them to the trees using the *Material Editor*.

Vegetation
Using vegetation objects, you can create a large area of ground cover by selecting different species of plant life and duplicating. Select the plant, hold down the modifier key (Control on Windows, Command key for Mac) and click the D key. Then drag and place the plant life where needed.

e-on software vue d'esprit

artist shannon howell **title** encounter

Haze

Creating fog or haze for a scene can easily be achieved in the *Atmosphere Editor*. You can adjust how thick the fog will be or how distant it is from the main camera as well as controlling its color. Placing objects in the fog and further from the main camera creates the effect of depth.

Ambience

By selecting a default volumetric atmosphere, then loading the *Atmosphere Editor*, you can adjust the behavior of the sun and light settings such as color, exposure, balance, and ambience. It's also possible to create a unique look by adjusting the fog settings.

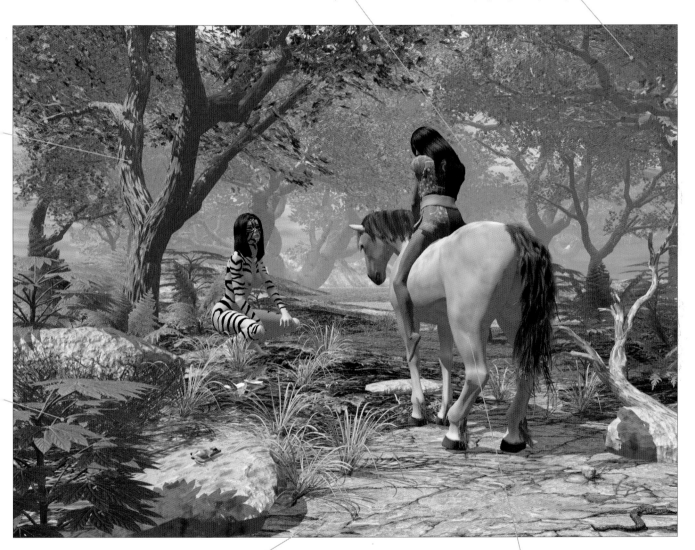

Earth

An easy way to create realistic-looking textures is to use real pictures (scanned in or taken digitally) of grass, rocks, or dirt. Pictures that show a mixture of all three create a more realistic appearance. Apply them using the *Material Editor.*

Characters

You can import people and animals from Poser 4 into the Vue d'Esprit scene by using the *Import Objects* menu option. There they can easily be scaled to the proportions required.

lightwave 3D cinema 4D

tools of the trade

ightwave 3D by NewTek is one of the most popular mid-range 3D applications around. Along with its rival, Maxon's Cinema 4D, Lightwave is a modeling, rendering, and animation tool with high-end capability but priced within reach of the amateur fantasy artist. Both packages support subdivision surface modeling and have advanced rendering facilities, thus offering a lower-cost alternative to Maya and Softimage 3D.

Lightwave is a program of two halves, *Layout* and *Modeler*, in reality two separate applications. *Layout* is mainly used in animation, but both can be used in the process of creating artwork. Lightwave has long been praised for its excellent lighting system and rendering engine, and the modeling tools are fast and comprehensive enough for most tasks.

Highlights include radiosity, ray tracing, and caustics, HyperVoxel volumetric rendering, basic hair and fur rendering, a powerful spreadsheet for tracking object parameters, a sky-rendering system called *Skytracer*, and *Digital Confusion*—an image filter that adds very realistic depth-of-field rendering effects.

Cinema 4D is also renowned for its rendering and lighting, especially its fast ray tracing. It features *BodyPaint*, a 3D painting component that allows paint to be applied to an object's mesh in real-time, including in ray trace mode.

In the image *Judith* by Daniele Duri, Lightwave was used to build and render the model entirely in 3D. Photoshop was also used, primarily for texture mapping the models, for adjusting contrast and color balance after the rendering, and to correct some shadows on the female model.

You can set up the entire scene, including all the objects, in *Layout*. Run test renders, adding point lights of different intensity, color, and falloff where needed. Position lights before the eyes and muscles, and near all other elements you want to bring out.

36

Coloring

The image is rendered and loaded into Photoshop for retouching. The overall image was desaturated, leaving only the glove to shine blood red. Still in Photoshop, the levels are corrected and an airbrush used to create the thin aura that glows around the figure's head and arms.

Modeling

In Lightwave *Modeler*, the full body of the figure is built, as well as eight different curved stakes and a black rope. Two simple planes are created for the floor and the wall.

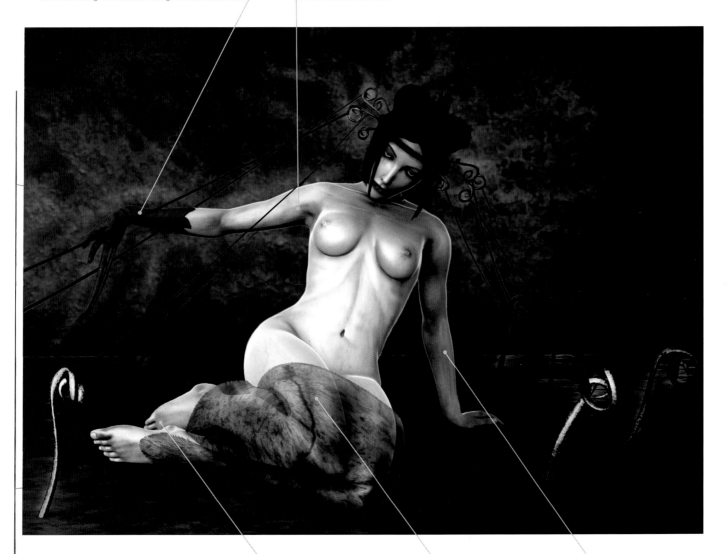

newtek
lightwave 3D,
maxon cinema 4D,
adobe photoshop

artist daniele duri **title** judith

Lighting

For lighting, you can use the *Global Illumination* setting or the radiosity engine. Alternatively, if you require a high contrast of blacks and whites—as in *Judith*—you can apply a more "traditional" lighting setup (lots of point lights and a single area light). In *Judith* the area light provides the greatest part of the lighting, but the point lights do all the subtle work. The area light is placed slightly in front of the woman, and a point light placed under the floor, to provide a reflective effect from it. Some negative value point light is also used for darkening some areas.

Surfacing

For surfacing, many procedural maps (mostly *Fractal Noise* and *Turbulence*) are used to give an overall grainy look. Procedural maps are useful, but there are parts that need specific detail. For example, the veins under the pale skin of the woman, as well as other little details, are painted using Photoshop, then applied as UV maps onto different parts of the body. For the wall, the floor, and the stakes, three large scans of rusted metal are applied in the same way.

Posing

Instead of going into *Layout* and constructing a bones system for the task, you can pose the figure directly in *Modeler*. This operation gives you all the control you need, not only for bending limbs, but also for displaying the amount of tension in muscles.

Watching how other artists work is a great way to pick up tips and new ideas. In the following pages, the work of some of the world's finest fantasy artists will be on display, broken down into steps that will take you through the process of creating superb artwork.

The step-by-step accounts contain a mixture of 2D and 3D techniques. The majority are based on the use of a single application, but the techniques can be applied to most other packages of the same type. In this section we will focus on:

Specific techniques: creating textures, including skin, clothing, and metal; creating realistic human skin and hair in Photoshop; using shaders and texture maps in 3D applications; creating human faces and expressions; and lighting fantasy scenes.

Fantasy creatures: creating the creatures that populate fantasy worlds.

section two
components & ingredients

Right
Smokin' is an example of Steven Stahlberg's texture creation technique.

Surfacing is as important as modeling in creating art using 3D applications. Determining the color, appearance, and texture of an object is part of the rendering process that turns collections of models and planes into scenes.

In 3D work, shaders determine the appearance of an object. These are the layers of attributes that make up how the surface of the model reacts to light—the color, reflectivity, appearance, and so on. Shader layers, known as channels, are given names to define their material qualities and their effect on the base layer, i.e *Bump*, *Highlight*, *Shininess*, *Reflection*, *Color*, *Transparency*, *Refraction*, and *Glow*. These are standard names for the channels, which can be found in most 3D modeling and rendering applications. Material types are also standard and are defined by how they react to specular highlights when rendered. They include *Lambert*, *Blinn*, *Phong*, *PhongE*, and *Anisotropic*.

Most high-end 3D software will include an editor where you can "mix" your own cocktail of shaders, organized in a hierarchy of effect known as a *Shader Tree*. Stand alone custom shaders as well as off-the-shelf collections are available.

Texture-mapping

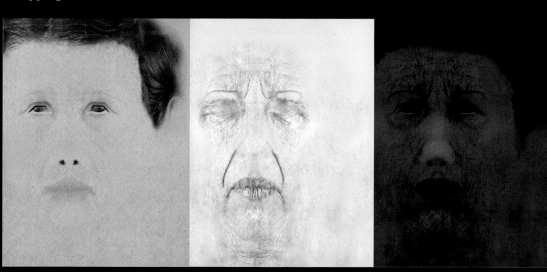

First create a model head in Maya. Then UV map the model of the head with a cylindrical projection using the *Polygon Projection* tools. Do a screen capture of the full-sized Texture Window in Maya. Create a very high-resolution square texture, for example 2k or 3k for the bump map, with a bit less for the color map. Import the screen capture into Photoshop on a layer of its own to use as a reference.

Import a digital photo into Photoshop to use as another reference, this time for matching the realistic texture of the skin. If you can, use a photo without any highlights in it, one that shows details like pores. Using the *Dodge* and *Burn* tools in Photoshop, it's possible to retouch highlights out of a photo while keeping most of the darker detail.

For the textures, start working on the Color map first because it can easily be used as the basis for all the other maps. Working again in Photoshop, leave everything that isn't bumps (veins, spots, and freckles) in the Color map and try to erase everything else.

The image shows how the Bump map (center) is left with all the wrinkles, while the Color map (left) has had them mostly erased.

The Specularity map (right) is bluish as a result of making the specular highlights on skin slightly blue-toned to counteract a tendency to go yellow.

Finally, map the photo onto the textures using the *Clone* tool or cut and paste, until it covers the whole texture in an appropriate way. Then it is ready for export back to Maya.

Texture maps are applied to the surface of a 3D object in order to give it extra detail. They can be created inside the 3D application using procedural methods or imported as 2D bitmapped images (file textures) from a digital photo. The resulting texture maps are assigned or mapped to points on the surface of the 3D object using the vertex coordinates of the polygonal model. Known as UV coordinates because of their relation to the U- and V-axes in 3D, these define the surface parameters of an object. Most modern 3D applications will include tools to "stitch" together UV texture maps and there are some stand alone tools for creating procedural textures. An example used by some of the artists in this book is DarkTree from Darkling Simulations (**www.darksim.com**), which is an application used to create highly complex and realistic procedural textures.

One of the main uses of UV coordinate texture mapping is applying realistic skin to the face and body of a figure created in 3D.

alias|wavefront **maya**

adobe **photoshop**

artist steven stahlberg **title** smokin'

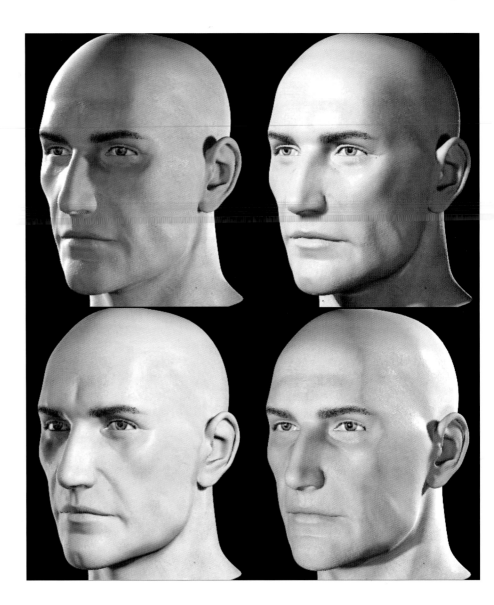

Skin is by far the hardest thing to imitate using computer graphics. One reason for this is its complexity, another is everybody knows exactly how it should look. We've evolved the ability to see very fine variations in it. There are two attributes that are more difficult to achieve than others—translucency and highlights. Translucency is a phenomenon often misunderstood, even by 3D artists and programmers. It is not the same as transparency. The lack of global illumination also causes problems, but is not specific to skin. Specular highlights change with the angle of the incoming light. They are much wider and brighter when the light bounces off the skin into the camera at glancing angles, rather than when the light is flatter (see image above). Subsurface scattering is also much more important to the final look of skin than most people might think.

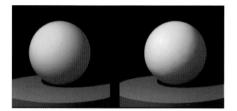

1 Here's a comparison of an average skin-colored shader on the left (rendered in 3ds max using Brasil), and the same image on the right retouched in Photoshop to look more like skin. You can see that basically the lit side needs to be flatter, wider, and cooler—coolest in the highlight. It is simple to do this in Photoshop, but in 3D software, such as Maya, you have nowhere near this level of control.

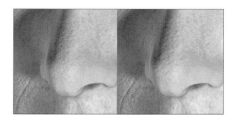

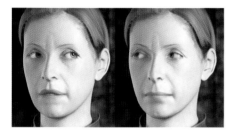

2 In creating a four-layered shader you can attempt to simulate roughly the translucency and the highlights of skin. The order of the layers does not matter, except that the base must be at the bottom, of course. The layers are: 1. Faketranslucency 2. Glancespec 3. Flatspec 4. Lambert base

Apply the color map to the Lambert base. Also apply one version of the bump map here, but make it a lower frequency and resolution, with bumps that are bigger but not too high in amplitude.

3 In the transparent specularity layers (there are two used here, but you could use only one), place a finer, stronger bump map. The left half of the image shows the finer bumps placed in the bottom Lambert layer. On the right the finer map has been moved to the specular layer, and the larger bumps applied only in the bottom layer. The left one looks more opaque than skin, while the right one looks more natural.

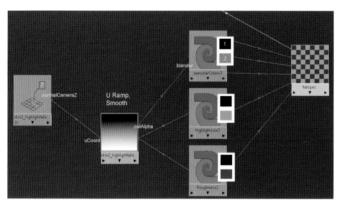

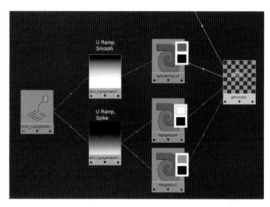

4 The two specular shaders, the Flatspec and Glancespec layers, are transparent PhongE shaders, one for glancing light, one for flat light. All three highlight parameters in both shaders have also been mapped to provide more control.

5 The SamplerInfo node adjusts the *Roughness*, *SpecColor*, and *Size* parameters of the shader in accordance with the incoming light. If the light is glancing, the Glancespec layer will show a very wide and bright (and slightly bluish) highlight, and the Flatspec will show nothing. If the light is flat the Glancespec will show nothing, and the Flatspec will show a softer, smaller (still bluish) highlight.

After the Ramp has been adjusted to what you feel works best, the only parameters that should be tweaked are the colors of the non-black blend nodes—leave the blacks the way they are.

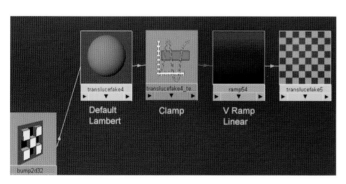

6 The "Faketranslucency" layer is based on a cartoon shader by Tom Kluyskens, used in the incandescency channel of a transparent Lambert. Another default Lambert is used with a Clamp node to provide a grayscale mapping from dark to light. This then gets remapped with whatever is in the V Ramp there. For skin shading, it's usually desirable to cool down the brighter parts and warm up the darker parts of the surface.

discreet **3ds max,**

alias|wavefront **maya,**

adobe **photoshop**

artist steven stahlberg **title** techniques

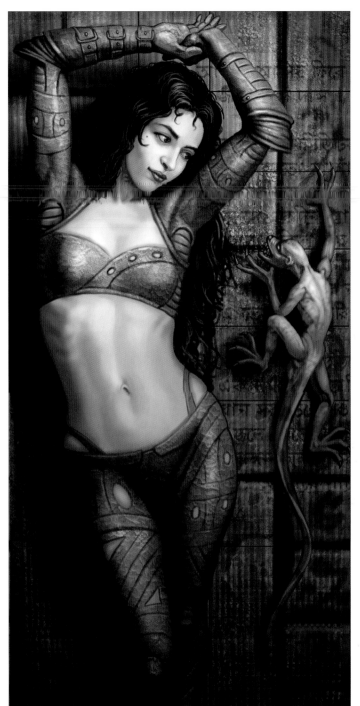

Photographs can provide an ideal way for bringing realistic textures to your digital painting. Photoshop has a variety of *Pattern* tools that you can customize and adapt for use in this way. As well as the individual tools used to paint textures onto the "newsbringer," *Fill Layers* can be used to apply patterns over the entire image. In a departure from previous methods seen is this book, this painting was started with a rough sketch of the composition using a drawing tablet, thus working on the computer from the very beginning of the project.

adobe photoshop

artist jhoneil centeno **title** the newsbringer

I When sketching, it helps to stay
close to the final color of the
finished artwork. In *The Newsbringer,* a
neutral gray-brown is a suitable
background color, and a light gray color is
good for the actual sketch. Using the
Paintbrush tool in Photoshop gives the
lines an uneven thickness, making the
drawing more interesting. After the
sketch, begin blocking out the forms on
another layer on top of the drawing. This
process does not have to be too accurate.
The main purpose is to get a rough idea
of how the finished painting might look.

2 On a third layer, start working in the
details. You don't have to have a
special Photoshop palette for skin
tones—instead use the default swatches
in Photoshop. You can also load in a
photo with colors that you like and
sample colors from it. The figure is on a
separate layer from the background color
to make it easy to change the
background, which is the next step.

3 For textured walls, you can take a digital photo of a concrete wall and use that as
a pattern. To do this, use the *Rectangle Marquee* tool on the open image to select
an area to use as a pattern. Feather must be set to 0 px. Choose *Edit > **Define Pattern***
and enter a name for the pattern. Select the *Paint Bucket* tool and set its *Fill* option to
"pattern." Fill a layer and set that layer to overlay mode on top of the neutral gray-
brown color of the original sketch.
 Load another digital photo of rocky ground and define that as a pattern. Using
the *Pattern Stamp* tool, draw on the wall with it. This adds more roughness to the
wall, making it more interesting to look at. Take the *Airbrush* tool and, setting the
painting mode to overlay, start to add the rusty colors and the lines to define the
individual panels.

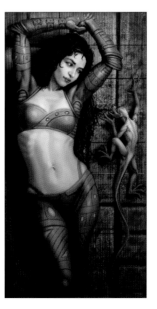

4 Make a copy of the figure, turn it
black, and set the layer mode to
multiply. Then position it so as to make
a cast shadow for the figure, with both
layers on top of the background. On top
of all this, add another layer in multiply
mode and draw subtle shadings to make
the picture more dramatic. Then add a
color adjustment layer and push all the
colors toward a more brownish tone to
harmonize the composition. Add more
detail and color in the background at this
point. Try adding *Gaussian Blur* to the
shadow, then skewing it a bit to give it
more dimension.

5 The lizard, the "newsbringer,"
is put on the same layer as the
woman, and his shadow on the same
layer as the woman's shadow. To finish,
photograph some tree bark and load it
as a *Pattern.* On an overlay layer, start
painting the texture for the woman's
outfit with the *Pattern Stamp* tool.
Add an orange reptilian pattern to the
"newsbringer's" body by hand. To finish
off, put a *Color Dodge* layer on top of
everything and add highlights to make
things stand out a bit more.

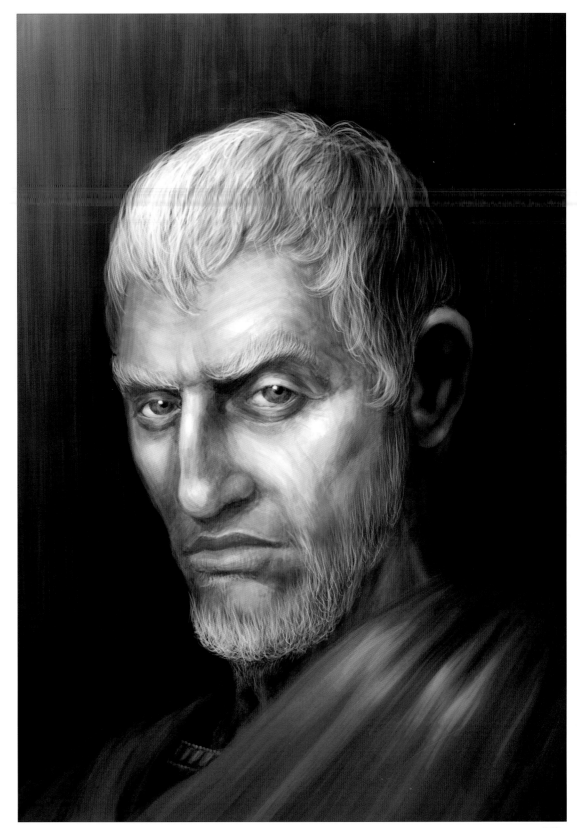

1 Begin by roughly sketching out what you want to paint. For *The Druid* the image was scanned at 300 dpi as a grayscale TIFF, then imported into Photoshop and cleaned up by adjusting the brightness and contrast. It was then resized to 8 x 10 in. *Colorize* (under *Hue /Saturation*) was used to achieve a dark sepia tone all through the digital canvas.

2 You are now ready to start painting in Photoshop, perhaps using a large round brush, about 70–80 pixels. At first there is no need to worry about making the brush strokes appear smooth. You can set the opacity level at 70% and paint away without thinking, simply having fun and laying down the colors to give the painting some shape.

The traditional method of using transparent brush strokes to lay down acrylic or oil paint works well with digital painting. This is especially the case if you have a well-rendered drawing and you want to add layers of paint to it. The method gives more control over the overall image until the illustration is complete. Here a Wacom Intuos Drawing Tablet was used for finer control and to replicate further the traditional feel of the process.

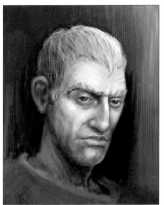

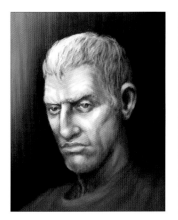

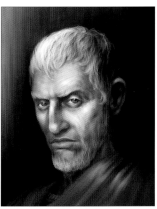

3 In *The Druid* complementary colors were used—warmer reds for the foreground figure and cooler greens for the background. In order to prevent the skin tones looking too even all over the druid's face, his nose, cheeks, and lips were made more reddish than the rest of his face. His forehead was made more yellowish, and his beard and neck more bluish. These can be taken as some general rules for older male figures.

4 One useful trick is to flip the whole canvas horizontally to detect any flaws in the painting. Continue doing this until the very end, perhaps even flipping the canvas vertically sometimes. You can progressively adjust the brightness and contrast settings, as well as hue and saturation, to achieve a richer look.

5 Take the painting into Painter to give it some smoother, more natural-looking brushstrokes. The fine brush can be used to continue adding highlights and blend some of the background colors together. Roughly estimate the shadows and add some cast shadows underneath the nose, chin, and eyebrows. Remember, the brighter the light source, the harsher your shadows will be. As you get closer to completing the painting, smooth out the rough edges by reducing the brush size, zooming in more and working on the details.

6 Back in Photoshop, add more and more fine strands of hair to the head and beard. Finally, go over the entire painting and make corrections and adjust colors until you are satisfied with it.

adobe photoshop corel painter

artist michael yazijian **title** the druid

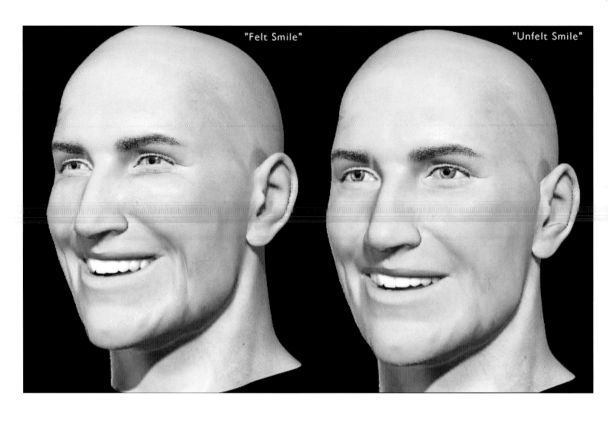

"Felt Smile"

"Unfelt Smile"

Before setting out to create a face for one of your characters, decide what the face is going to look like and then find reference images for it. Try to find out what most people have in common concerning facial features and expressions. You can often re-use the same face for different characters, since so many things are the same in every face. The face used in the following technique is an average, idealized male face, aged somewhere between 25 and 45.

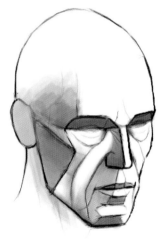

1 Here are the major shapes and planes of the male head, exaggerated for clarity. Most of the red lines here are only visible at old age or in extreme expressions, but should be planned for in the geometry all the same. As all humans have very similar potential wrinkles and folds, this very same face can, and should, be used for any sex, ethnic group, and age group, except the very young.

2 The blue lines indicate a first attempt at sketching the topology. Start by simply extending the red lines, placing more blue lines along the areas of highest curvature (jaw line and brows, etc.), and then try to interconnect them without getting too many long, thin rectangles, or making the corners much less or much more than right angles. You can see there are some areas that are much trickier to plan than others.

3 This close up shows the trickiest area of all: the outer eye corner. It's not that bad in a young person, but in older people you have to be very careful. Note that in some people one or the other of these two upper wrinkles never becomes visible until very late in life.

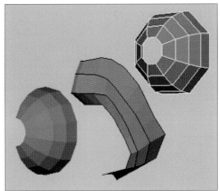

4 Start with a simple polygon object, a sphere or a box, or even a polygonized NURBS surface. It does not really matter, as long as you end up with a polygonal surface looking roughly like the sketch you did. Use whatever tools you're more comfortable with—you could even use another software application, then import from it.

Create some degree-1 NURBS curves, following your sketch. Then skin them, selecting polygons as output. Next create two polygonal spheres (in this example, one sphere is 14 divisions around and 10 high, the other 8 by 10). Align them with one pole facing forward. Delete the far half of both, and also the left side of the 8 by 10, and also the center row of polygons on both.

5 Push and pull points into shape. Model the mouth to be slightly open—this is a good neutral pose. Then add three more curves going across the forehead to the temples.

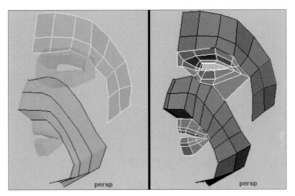

6 Attach these polygons to each other, using first *Combine*, then *Merge Vertices*, and fill in the holes using *Append Polygon*. Use the *Split* tool to create new edges, and delete the old ones. Then delete any vertices not needed anymore (simply by selecting all vertices in the area and pressing "delete").

7 After these initial stages, go to work on the full head. From here you can *Append Polygons* until the whole head is finished. When you are satisfied with the topology, convert to *Subdivision* surfaces (using the *Create Subdiv* command) and start editing on the higher levels. Be prepared to go through a few false starts. Some problems don't become apparent until you start modeling on a higher level.

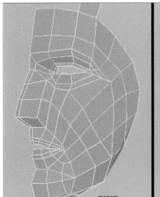
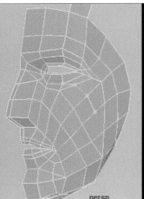
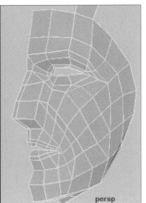

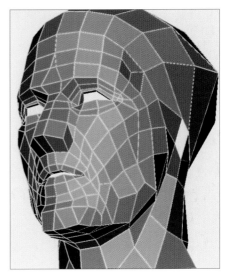

alias|wavefront maya

artist steven stahlberg **title** smiles

A key point to remember when creating hair is that it flows like water. It drapes and rarely has any angles. Even when dry, hair tends to flow in odd-shaped ribbons or sections. Think of it as fluid, like water in a stream. It might part here or there for an ear but usually it follows gentle curves and obeys the laws of gravity from the top of the head to the sides, just like a waterfall. If you keep a natural flow to the shapes, your hair will have more realistic results.

adobe **photoshop**

artist kristen perry **title** teryn

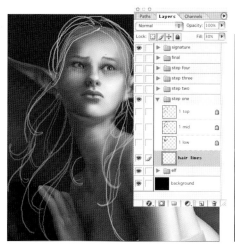

After creating the other elements of the figure, very loosely paint in the general shapes for the hair. Make a new layer.

2 To make more sense of the shapes, take the *Pen* tool and create a path for the sections of hair. Use the drawing as a general guide. Select the path and click the arrow at the right corner of the paths palette. Fill the path with a light brown to begin with. Lock the layer and take a large fuzzy brush with a dark, rich brown set to about 45% opacity in *Multiply* mode. Streak some shadows of color onto the sections, leaving the lighter areas to suggest highlights.

3 To create more realistic hair details, take a small hard brush (about five pixels will do) set to 85% pressure with the smudge tool and drag full strokes following the movement of the hair sections. Then start in the middle of a highlight or a shadow to get finer details—always dragging from the ends will zigzag the hair instead of adding strands.

Use a thicker hard brush to make some more dramatic sections. Be careful how you do this as it can quickly get out of control. Hair can look a little ratty because it's pulled from the inside out to little spurs of strands. Go for long flowing lines.

4 Take a large fuzzy brush (200 pixels or so), set to *Multiply* and an opacity of about 45% with a rich medium brown, and shade the layers to add more depth to the shadows. For the highlights, choose a light, warm brown with the same brush, set to *Color Dodge* at an opacity of about 19%, and lightly build up some brightness in the highlight areas of the sections.

On the hair section ends, turn off the layer lock and take a hard eraser (the *Spatter* 12 pixels brush in particular) and make it fade in size to 0 in about 53 steps. Then rough up the edges a bit to make the end of the hair softer (*see* inset a).

5 The hair will look fuzzy except for perhaps a strand or so (*see* inset a). To create some more stray strands, first make a new layer. Taking colors similar to the area of the hair next to the strand, use a small hard brush (around 5 pixels, but vary for each strand). Under *Brush Dynamics*, set its *Size* to *Fade* at about 250 steps. You can then fade color from the foreground color to the back. Remember to follow the general direction of the hair sections!

For strand color touches, lock the layer and gently tone the strands as needed with *Multiply* and *Color Dodge* brushes.

For the final look, flatten all the hair layers and lock the resulting layer. Taking environmental colors (in the case of *Teryn*, steel blues from the fog), tone the outside of the hair with a large fuzzy brush set to *Hue* (29% opacity) or *Color* (12% opacity). Make sure the outline of the hair blends in slightly with the background. This will make the hair look more natural. Then, on a *Multiply* layer below the hair, brush in a build up of shadow using a deeper brown. For extra spice, again take a *Color Dodge* small brush and drag in some highlights. All done!

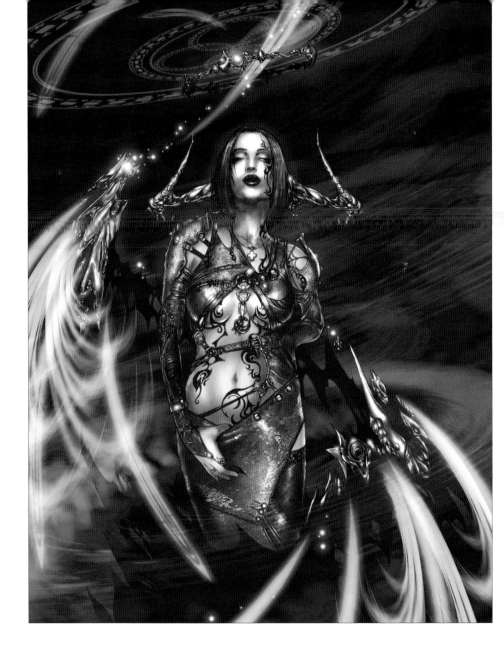

Lighting a scene is an art in itself and there are many software packages that allow you to add light and texture to artwork. As well as 3D applications, where you light a model in a similar way to a photographer's studio lights, image editors such as Photoshop possess arrays of filters and lighting effects that you can easily apply for a variety of effects. There are also, of course, more basic "handmade" ways of building up realistic lighting and textures in artwork, using just brushes, color, and the properties of layers. The techniques shown here can be applied to almost any layer-based, image-editing application. It all depends on the skill of the artist and an imaginative approach to basic software tools.

1. Scan a rough sketch, with shadows applied directly on the drawing, into Photoshop. Raise the contrast and brightness a bit to clean up the image. Outline each area, such as the skin, clothes, and hair, and adjust their color with the *Color Balance* option. Save the image as a PSD file. Mark out an area like the skin or the hair with the *Polygonal Lasso* tool and fill the area on a separate layer with the brightest color you expect that area to be the in the final image. Repeat for the rest of the details and also the background, each on a separate layer. Use the layer option *Multiply* and choose the option *Preserve Transparency*.

2. Choose the *Brush* tool and set the intensity to 6–7%. This way you can work more precisely. Start with the skin, then the eyes and the hair. Choose a color that will be the darkest tone in the shadow and start shading the area with the *Brush* tool. If you use two different colors for shading, you can simulate the effect of a second or a third light. Try to mix some blue in the deep shadow area to make the look more natural.

3. After shading, start to apply some texture (using retouched digital photos) to different colored areas, like the clothes or background. Import and place the texture on a new layer and set the layer option on *Overlay* or *Soft Light*, adjusting the brightness and contrast to your satisfaction.

4. Make a new layer and set the layer option to *Color Dodge*, then choose the *Brush* tool and set the pressure option on 3%. Paint on the empty layer to make certain areas brighter, to create some metal and sparkling effects on the eyes or hair and crystals. Adjust the opacity of the layer to find the best look.

5. You don't have to use *Lens Flare* filter or any other filter to create flares—the *Brush* tool works just as well. Open a new layer, fill it with the color black and paint a big red spot with the brush. Select a smaller brush, choose white for the color and simply paint over the middle of the red spot. Raise the contrast of this layer until the flare looks good enough; avoid raising the brightness. Set the layer option to *Screen* to make all black areas transparent. You can then move your lens flare to the desired location on the image with the *Move* tool. To create many flares, duplicate the layer and change the size each time.

6. In a similar way, you can create all other lights and bright objects on black layers. For this image, some light wings were created with the *Brush* tool and *Motion Blur* applied to them. After all the color, texture, lighting, and shadow work is done, merge all the layers into one and save the image. Then adjust the color and saturation to suit your preference.

adobe photoshop

artist andre weiss **title** vampire goddess

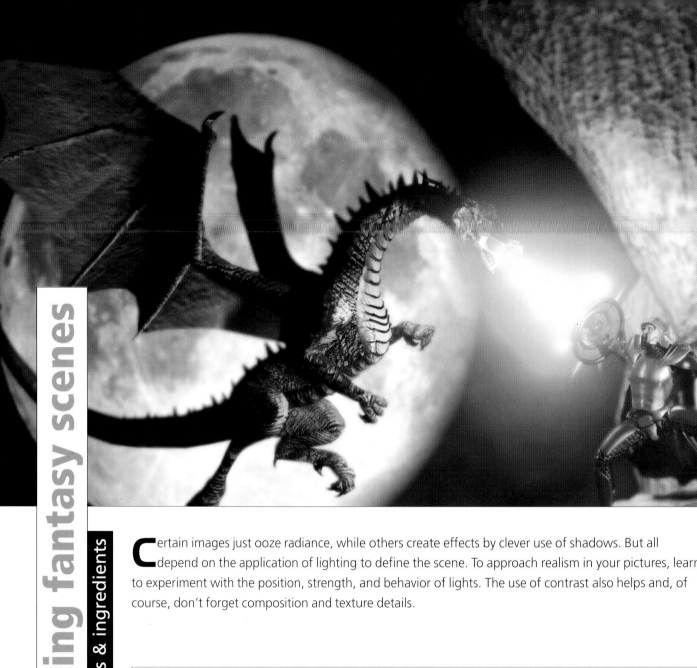

Certain images just ooze radiance, while others create effects by clever use of shadows. But all depend on the application of lighting to define the scene. To approach realism in your pictures, learn to experiment with the position, strength, and behavior of lights. The use of contrast also helps and, of course, don't forget composition and texture details.

curious labs **poser pro pack,** e-on software **vue d'esprit,** adobe **photoshop,** daz productions **dragon model,** blbarret **knight model** (aka **strongblade**) from renderosity (www.renderosity.com)

artist michael loh **title** dragon quest

1 In Vue d'Esprit, create a new scene using the Black Back atmosphere. Then remove the sunlight and ground objects from the World Browser to obtain a dark environment.

2 Using Poser Pro Pack, load and pose models of the Knight and Dragon and export them together to a file in the ".obj" format using the default export settings. Import the ".obj" file into the Vue scene. Put the Knight and Dragon into separate layers and reposition them to fit into the camera frame. The camera angle shown here displays most of the object's surface area.

3 The next step is to create the rocky ledge and cliff wall. For this, use the Rock object that comes with Vue. Rocks are created randomly by Vue and with this function create nine Rock objects. Then proceed to resize, rotate, overlap, and arrange them until you are satisfied with the composition. Use the object material editor on each of the Rock objects to tone down the default highlight and bump values, as they can sometimes look too bumpy and shiny. We used: **Highlight global intensity:** 40%; **Highlight global size:** 25%; **Bump gain:** 0.750.

It helps to put the objects into layers. You can make each layer invisible to remove clutter from the screen as you work with each individual object.

4 The fire streaming out from the Dragon's mouth was created using 13 point light objects. String and position the lights into a triangular shape. Each of these lights should have the following characteristics: **Power:** 5–11; **Color:** Red: 248, Green: 149, Blue: 115; **Softness:** 5%; **Volumeteric lighting:** Enabled; **Volumeteric intensity:** 0.10–0.20; **Casts shadows in volume:** Checked; **Show smoke or dust in light beam:** Unchecked.

The intensity of the lights increases incrementally as they get closer to the Knight's shield. String the lights close together to eliminate the transition effect between the lights. Increasing the intensity of the lights also reduces this effect.

5 To illuminate the Knight, create a Spotlight object and position it in front of and to the right of him. Each of these lights should have the following characteristics: **Power:** 5–11; **Color:** Red: 248, Green: 149, Blue: 115; **Softness:** 5%; **Volumeteric lighting:** Enabled; **Volumeteric intensity:** 0.10–0.20; **Casts shadows in volume:** Checked; **Show smoke or dust in light beam:** Unchecked.

To bring out the outline of the Dragon, you can create a Planet object and position it behind the Dragon, with the following Planet settings and then broadcast-render the image: **Planet:** Moon Phase: Full; **Brightness:** 50% **Softness:** 50%.

6 Vue provides a way to add depth to a picture by setting the *Focus* and *Blur* properties of the camera object. However, if you have Photoshop, an easier and quicker way is use layer masks and *Gaussian Blur* to create this effect.

In Photoshop, load in the final render. Create a new layer with a copy of this image and call this layer Normal. In the *Gaussian Blur* setting, use a blur value of 5 to blur the *Background* layer. Then reveal the layer mask for the *Normal* layer and fill it with black. With the *Airbrush* selected and set with a pressure of 65% and size of 200%, proceed to unmask the foremost features of the image to give it the desired illusion of depth. Finally, flatten and save the image.

This futuristic torpedo seems to have a life of its own, its sensor glowing with malevolent energy. It also provides us with an example of creating fairly simple, inorganic objects through the method of extruding shapes and defining surfaces from NURBS curves and primitives. In Maya, in addition to tools capable of manipulating NURBS, the *Loft* function and *Revolve* tool can be used for quick object creation. Lofting is where a surface is applied to a series of profile curves that defines a frame, while the *Revolve* tool creates a surface from a profile curve that revolves around a defined axis.

alias | wavefront maya

artist adrian smith **title** torpedo

62

1 Begin by using a NURBS cylinder for the main part of the torpedo's body. The rest of the construction will be created around this cylinder shape. Build up the front of the torpedo using a series of circles and quadrants. Revolve the two quadrants by 360° to make two different surfaces. One should be transparent so that you can see the housing containing the torpedo sensors.

2 The head of the torpedo is nearly complete. All that is needed are two more surfaces to create the impression of a camera sensor inside. Loft two circles together to produce a conic section and revolve a smaller quadrant to create a lens.

3 Now for the tail of the torpedo. The tapered section is built by lofting two circles together and adding another NURBS cylinder. Finish the end off with a revolved radius.

4 Now to construct the propeller housing. This is simply an ellipse. Scale it in the Y-axis, translate it in the Z-axis and then translate its local axis back to 0 in the Y-plane. Again the ellipse should be revolved.

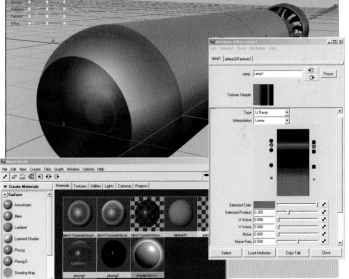

5 The propeller blade is built by lofting three ellipse curves together. The ellipses can be created by first scaling a circle in the Y- and Z-axis. Then copy and translate it in the X-plane with a 10° rotation in the X-axis for the first copy and 20° for the next copy. Loft the ellipses together. Move the axis of the blade back to 0 in the X-plane. Copy it 11 times and rotate it around the Z-plane by 30° increments.

6 All that is needed now is to apply surface textures. Apply an environment map on a *Blinn Shader* node to the surface of the main body, with a fractal noise added to a bump map to give some surface irregularity. The camera map is a color ramp texture on a *Phong* shader applied to the surface with some incandescence so that it glows red. Add a *Blinn Shader* to finish off the transparent front of the torpedo. There is no need for added maps, just a simple *Blinn*.

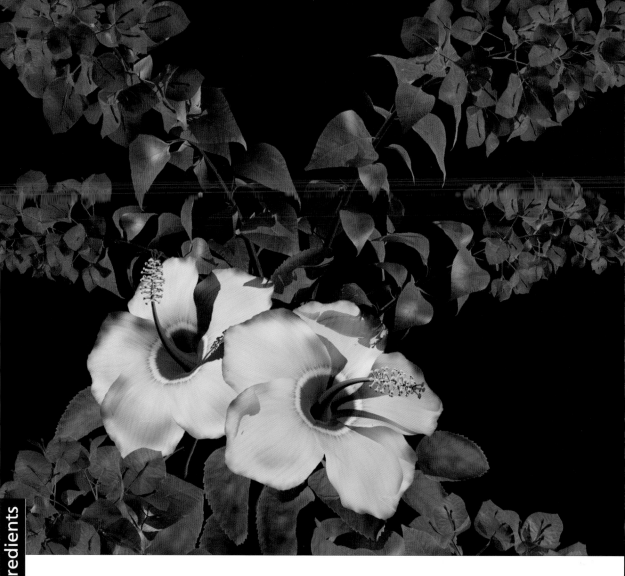

organic objects: leaves

components & ingredients

The simple leaf can be used as the basis for all manner of fantasy flora. From the myriad examples found in the background on every pastoral scene to those adorning the bodies of Green Men and other mythological characters, leaves have an infinite variety of uses.

adobe **photoshop** discreet **3ds max**

artist frank vitale **title** creating a leaf

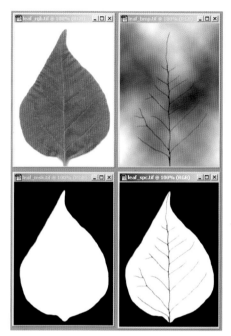

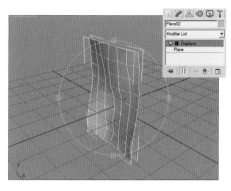

The RGB component or color map (top left) is a scan of an actual bougainvillaea leaf. The additional maps were painted in Photoshop using the scan as a template. To create the bump map (top right), use the color map as a template, and on a new layer paint black lines over the major veins in the leaf. Load this layer as a selection and save as an alpha channel. Go to the alpha channel and blur the lines a bit to soften any rough edges, then use *Levels* to tighten them up. Using a large soft brush, paint away the tips of the lines. This will soften the transition and make the veins look more natural. Now use this channel to fill the vein layer with a more natural looking set of veins. In the base layer, apply *Clouds* with black and white. This will create a natural looking but uneven relief on the surface. Flatten, delete the channels and save as leaf_bmp.tif for your bump map.

The mask (lower left) is simple. Just outline the leaf slightly inside the edge. The black area will be cut away and the white area will remain opaque. Make the specularity (lower right) map mostly white with the veins in black. This will allow the leaf to reflect a specular highlight but not the veins.

Open the *Material Editor* in 3ds max and select another material slot. Name it leaf face. Set the *Specular Level* to 18 and *Glossiness* to 43. Expand the *Maps* rollout and under *Diffuse Color* use the texture leaf_rgb.tif; for *Specular Color* use leaf_spc.tif; for *Opacity* use leaf_msk.tif and for *Bump* use leaf_bmp.tif.

2 To create a natural leaf shape start by creating a flat plane in the front viewport. Set its length segs to 8 and width segs to 6. Be sure to check *Generate Mapping Coords*. From the *Modify* tab add a *Displace Modifier* to the flat plane. Click on the button for *Map* and choose the leaf_bmp.tif that you just created. At the top of the *Parameters* rollout is the spinner for the strength of the effect. Drag the spinner to achieve the amount of displacement you are after. This is a true amount relative to the scale of your scene. In the image here we can see the amount of displacement. The polygons may look a bit rough but that will not matter, as the only job they need to serve is to undulate the surface. The edge of the leaf will be cleanly cut away by the opacity map.

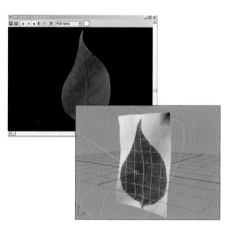

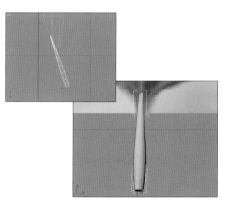

3 Here you can see the leaf applied to the model as well as a render of the leaf. Add a spotlight to make the shape of the leaf stand out.

4 The leaf stem is created by tweaking the vertices on a cylinder. Create a green material with a *Specular Level* of 24, *Glossiness* of 36 and a *Diffuse Color* of R:119, G:122, B:51. Apply the material and align the stem to the leaf using the *Move* and *Rotate* tools.

5 Once attached, use a *Bend Modifier* on the stem and the leaf to get a naturally curled shape. Set the angle to 95, the direction to 85 and the bend axis to y. This should give you a satisfactory result.

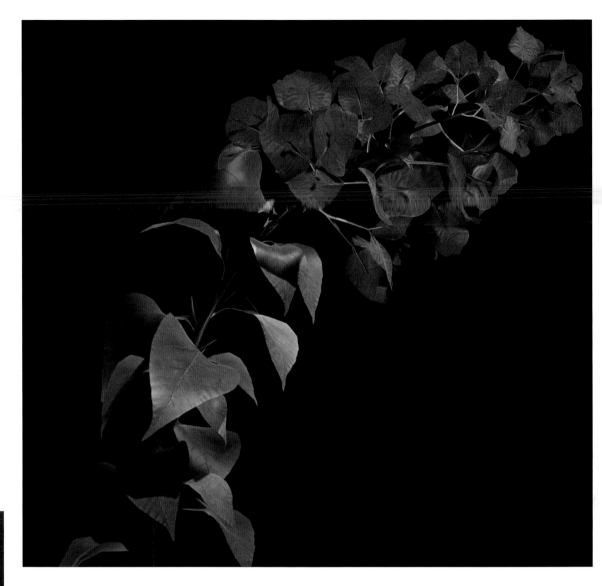

Creating plants in 3ds max is fairly straightforward. Here we will concentrate on creating a simple branch and then attaching some leaves (using a leaf that has been created as described on the previous two pages). From there you can adapt and develop your skills to produce other plants, trees, and organic material.

adobe **photoshop** discreet **3ds max**

artist frank vitale **title** creating branches and plants

2 Now create texture maps using Photoshop. For the color map (left), create a new document measuring 100 x 600 pixels and colored light and dark brown. Run the *Clouds* filter and add some *Noise* and *Blur*. Next run a *Motion Blur* to achieve vertical lines. Perform an *Offset* in both vertical and horizontal directions to reveal the seams and then use the *Rubber Stamp* with an elongated soft brush to eliminate them. Save this file as stem_rgb.tif.

To create the bump map (right) use the *Airbrush* to paint a series of squiggly vertical lines, trying to end in the same horizontal position as you began. Do these in three separate channels, not on layers. Offset each channel and eliminate the seams as before. Load these channels and fill into three separate layers. Offset the layers to get the distribution of lines that you want. When you are finished, flatten, delete the channels, and save as a grayscale file.

In 3ds max open the *Material Editor*, select one of the material slots and name it "branch." Set the *Specular Highlights* to Level 40 and *Glossiness* 50. Click on the *Diffuse Color* slot under *Maps* and choose the stem_rgb.tif texture you created. Click on the blue and white-checkered box icon so the map will display on your object in the modeling windows. Next add the bump map in the same manner but do not click on the checkered box.

Click on *Self Illumination* and add a falloff map. Set the colors to black for the top swatch and R:199, G:152, B:24 to the bottom swatch for a golden color. Make sure it's set to *Perpendicular/ Parallel* for falloff type and *Viewing Direction* for falloff direction.

1 Open 3ds max and save a new file as branch_01.max. Make a small circle in the left viewport—this will represent the diameter of the branch. Create a spline next to it, running vertically to represent the length and shape of the branch. Select the line, go to the *Modeling* tab and choose *Loft Compound Object*. Go to the *Create* tab under *Creation Method* (make sure you are set to Instance) and select *Get Shape*. Now select the small circle and you will have a loft object. Switch over to the *Modify* tab and expand *Deformations*. Set the beginning scale to over 100% and the ending scale to around 20% to create the taper in the branch. Select the branch object and on the *Modify* tab under *Surface Parameters* you will see *Mapping*. Check *Apply Mapping* and set the length repeat to 1 and the width repeat to 1. Make sure the *Normalize* box is checked: this allows for consistent mapping along the length and around the circumference of loft objects.

3 The *Mix Curve* controls the intensity of the effect. You can add, delete, and manipulate the control points throughout the icons above the curve. Go back to the top level of the branch material, select the branch in the viewport and click the *Assign Material to Selection* icon in the *Material Editor.*

4 To populate the branch with leaves, position the leaf you have already created toward the bottom of the branch and align it so the leaf stem intersects the branch. Go to the *Hierarchy* tab and select *Affect Pivot Only*. Now when you rotate the leaf it will rotate about the tip of the stem making manipulation much easier. Instance (clone) the leaf by using the *Move* tool, making sure you are set to *World Space*. Hold the shift key down while moving the leaf. When you release the mouse button, a dialog will come up. Choose *Instance* and set the number to 5. Position these five leaves along the stem spacing them in as natural a way as possible. Be sure to give them slightly different rotations and scale them either slightly smaller or larger, whatever it takes to achieve balance.

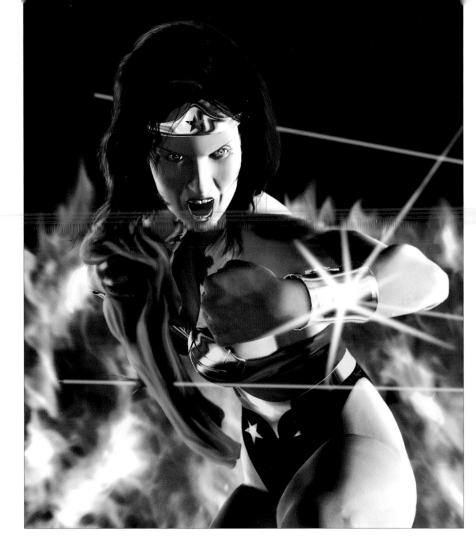

Superheroes are most commonly found in comic books, but their world of magic and superhuman powers also make them an ideal choice for the fantasy artist. Here the figure of Wonder Woman, the amazon princess created by DC Comics, has been given a new 3D lease of life in Curious Labs Poser. Daniel Murray wanted to show the character is such a way as to portray strength, courage, and power. Poser has its limitations, but it is a quick and easy package for modeling the human form.

curious labs **poser**, adobe **photoshop**, daz productions **'victoria 2' model**

artist daniel scott gabriel murray **title** wonder woman

1 The model that will become *Wonder Woman* is an advanced Poser model, with many controls that allow you to shape, bend, and manipulate. The infant shown is a stock Poser model. Models in Poser, as in most other 3D software, are covered with texture maps. For *Wonder Woman*, a freeware set of props, which included her costume requirements, was located on the Internet.

2 Once you have manipulated the model in a pose that you like, you can add lighting, change reflectivity, and add bump maps. When you are satisfied with the overall feel, you can render the image for output to Photoshop. Poser can render entire scenes, but the effects shown next are easier to create in Adobe Photoshop.

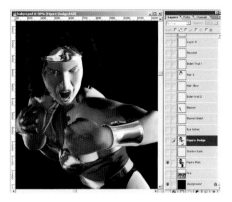

3 In Photoshop, select the gray background and remove it. Add a black background. At this point you can use various tools in Photoshop to clean up the image. Fix joints that have crinkles, adjust the costume so that the woman's skin does not show through in the wrong places, smooth edges that have that distinctive digital feel and generally tighten up the figure to get it ready for the next stage.

4 Duplicate the image and set the layer to *Dodge*. Use the *Dodge* tool to enhance edges where more light is needed for effects such as fire. Again, using the *Dodge* tools and varying brush sizes, touch up particular areas such as the woman's eyes. Dodge and burn (using the *Burn* tool) areas of her costume that require more shine. Using the *Airbrush* tool, you can add small shadows to areas that did not get covered in the Poser render. These areas are usually where clothing meets skin, her teeth and lips, and so on.

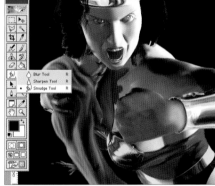

5 On a new layer you can add other elements, such as the soft, blue blanket covering the baby here. Essentially it is just a blob of blue with some lighter shades of blue mixed with white and black. Using the *Smudge* tool, you can manipulate the colors of the blanket as if it was colored sand. Again, using different brush sizes and pressures you can shape blobs of color into something that people will recognize as a baby blanket. When you're happy with the general form, return to the *Dodge* and *Burn* tools to create greater depth in the blanket.

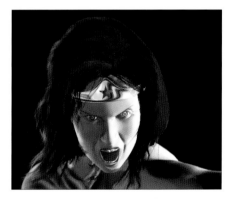

6 Start a new layer and begin to develop the hair. Using smudge techniques, create a haphazard hairstyle to invoke action and movement. In *Wonder Woman*, the *Airbrush*, *Smudge*, and *Dodge* and *Burn* tools were all employed for the hair.

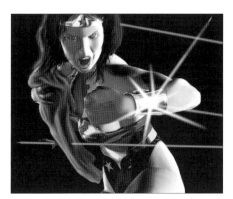

7 Turn the hair layer off. Create another layer underneath the hair layer and add some orange color with the *Airbrush*. This will serve as light coming through the hair. Continue to add detail such as eyelashes, walls, sky, more shadow work, and so on. The bullet trails give a sense of combat to the image. Add more dodge and burn as you go, airbrushing shadows, and so on. To finish, you can create some realistic-looking fire with the *Airbrush*, slightly blurring the background fire to separate it from the figure.

Vampires and the undead—ghosts, ghouls, mummies, zombies, and other animated corpses—are the subject of fable, faith, and fiction from many parts of the world. However, the influence of Hollywood has probably standardized their appearance in most imaginations. The shambling specter shown here is typical of the breed, its rotting body driven to stalk the night by a supernatural compulsion.

The basic figure of *Anubis* is a commercially available 3D model called "Michael" by Daz Productions, which is imported into Poser. Position is important in the undead. The model has been given many twists in order to create the feeling of a creature in torment and anguish. Poser allows this manipulation through a series of dials that move the model's joints into position.

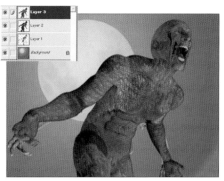

1 This image required several textures to give the effect of a tortured soul. These were created in Adobe Photoshop and wrapped around the digital model inside Poser. This created the "core" of the mummy. No texture is required for the skeleton as its use is limited. For an image like *Anubis*, first position the model correctly. Then—so that you can make the many holes, tears, and cuts—create three separate layers (the outer skin, the muscle, and skeleton), each with a separate texture map. You can use "bluescreen" backgrounds to make it easier to layer the images when you export the undead creature into Photoshop. With the textures applied after rendering, take the entire project into Photoshop.

2 In Photoshop, each mummy image has been imported into a single document and placed upon a separate layer. Photoshop allows you to select the entire blue area and delete it, leaving the main figure intact. This done, you can now start to erase, clone, and generally manipulate the image to give life to the dead.

3 Essentially, this technique is repeated for the entire skin section. With the Eraser tool selected, work on the skin layer. Select areas to be erased so that the muscle layer comes through.

4 With the areas erased, switch to the *Burn* tool, a tool that darkens the area being worked on. Switch to the muscle layer. Darkening the muscle near the edges of the "hole" lifts the skin layer away, visually creating depth. By selecting particular areas and continuing to burn, you can give the muscle a more injured appearance and more depth.

Create a mask selection on a new layer and switch to the *Clone* tool. Cloning allows other parts of the image—in this case, a hanging bit of skin—to be copied exactly into another area.

5 Burn and dodge the cloned area again. (Dodging has the opposite effect to burning, lightening the affected area to create fullness, and it needs to be repeated many times in the course of the creation of an image like *Anubis*.) Finally, choose a clean non-distracting background to highlight the image, add a bit of airbrushed fog, and the mummy comes to life.

curious labs POSER,

adobe photoshop,

daz productions 'michael'

artist daniel scott gabriel murray **title** anubis

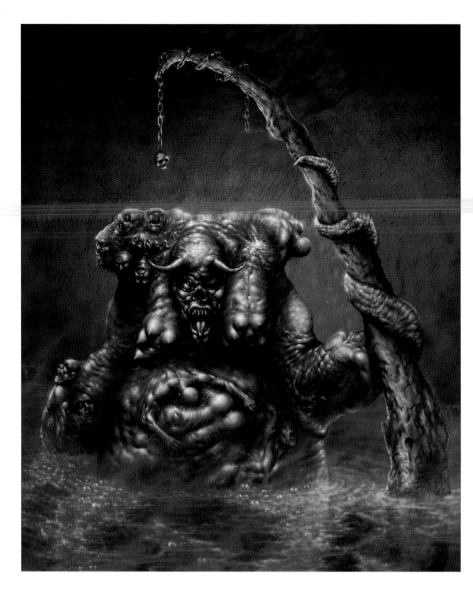

Demons come, of course, in all shapes and sizes. This one was inspired by a nightmare of the artist. Its skin is very rough and wrinkly, elephantine with many heavy folds. It has a large number of heads embedded in its shoulder as befits any self-respecting denizen of the underworld, and as it rises from its dark and hellish pool, we see a royal scepter in its tentacled grasp.

adobe **photoshop** discreet **3ds max**

artist roberto campus **title** demon (soul eater)

I Choose an orange background color because flesh tones can be easily rendered from it. Make a separate layer (set on *Multiply*) above the background. Sketch the main subject with the *Paintbrush* tool in *Normal* mode with a black smooth brush set on 10–50% opacity and varying in size from 5 to 80 pixels wide. For speed, work in a low resolution (72 dpi) and concentrate on roughing out the shapes, volume, and composition.

2 Resize the image to a higher resolution (300 dpi). In the sketch layer, use the *Eraser* tool (10–30% opacity, medium-sized, hard-edged brush) to lighten up areas that are too dark. Zoom in to 200% and where a highlight is needed, erase pixels to reveal the orange background below. Define the base texture of the skin by adding smaller highlights (with a 5-pixel-wide, hard-edged brush) where skin creases and folds should go.

3 Use the *Smudge* tool set to normal mode and 40% opacity with a brush size set from 10 to 30 pixels wide. The goal is to blend all the highlights you put in place before, making sure at the same time to shape all the skin folds and creases in a very organic way. After blending the highlights, use the *Paintbrush* tool to add detail to shadows that are lacking in strength. Apply short strokes of black pixels where needed and smudge and shape them.

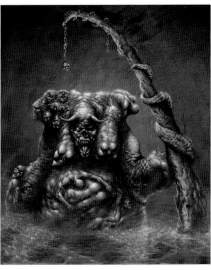

4 Flatten the main figure and the background layers into a single one. To create textures for realism, scan the skin on the palm of your hand at 600 dpi and open the new file in Photoshop. Create a seamless pattern (using the *Clone Stamp* tool to blend areas closer to the edges) and save the pattern as a PSD file. Apply the newly created texture to the demon using the *Texturizing* filter, setting its size at 150% with relief set on 10. Use the *Fade* command, set at a value of 60% to reduce the strength of the texture on the main figure.

5 Set the *Dodge* tool to *Highlights* and, starting from a red-orange base, bring up lighter oranges and yellow tones. Apply the effect on all the areas that require highlights using a small brush size and an exposure mostly set on 25%. For lighting up larger areas, use the *Paintbrush* tool set on *Overlay* with a light color (yellow and white) and opacity of 10%. Colorize a few details of the subject, such as the horns and teeth, to give them a more yellow appearance, and add smaller additional details.

6 For the background in this image, 3ds max was used to render a cave wall. You can do this by first creating a few rock textures in Photoshop, blending them together into a seamless pattern. Import the pattern file into 3ds max and assign it as a bump map and *Diffuse* material to an object that is illuminated by a single red light source. Go back to the demon's layer and erase everything around its edges so that only the demon remains. Load the rendered background image in a new layer and move it below the demon's layer. Clean up any stray pixels from the layers above the background and flatten the image. Adjust the *Image Levels* and *Colorize* it until you obtain a uniform feel and tone.

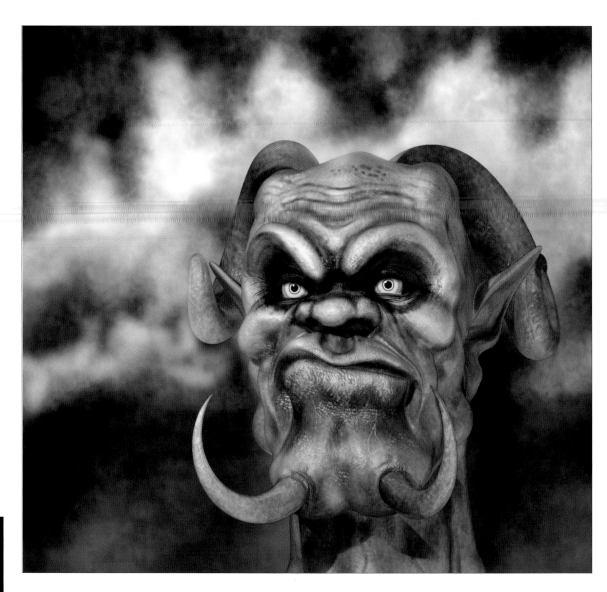

This demon image was created in ZBrush using a basic head model from a 3D sphere. The background was painted onto a canvas made from yet another plane. To sculpt a head like this, use the symmetry feature in ZBrush. This will allow you to model one side of the head while the software matches your moves on the other. The raised areas like lips and cheekbones can be pulled out to form the face very quickly. Sections of mesh can also be pulled out to create ears. Giving the model a very high-mesh resolution (i.e. a high number of polygons) makes it easy to add minute details like the nostrils. To add features such as eye sockets it is simply a case of "painting" on the head while holding down the CTRL key.

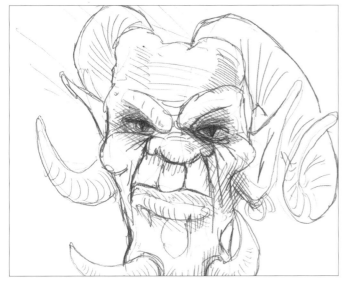

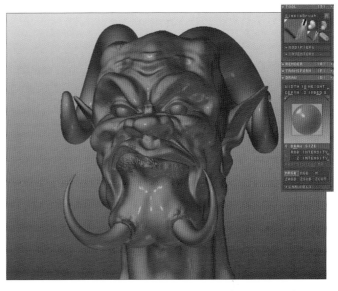

1 Draw a sketch beforehand to use as a template. More often than not the final image looks nothing like the sketch but this does at least help to get the proportions right. The sketch sits in a back layer and can be switched on and off as required.

2 When modeling a head of the type shown here—a very stern-looking creature with deep-set eyes and a massive chin—make sure you model the raised areas where other models or objects will interact with it. In *Razareal the Painweaver* there is a dint surrounded by a raised rim where the chin-horns meet the head, as you would perhaps see on a rhino horn. You can make the horns using the *Spiral* tool, which produces a pre-made spiral and allows modification of the settings to make it bigger or smaller in different ways.

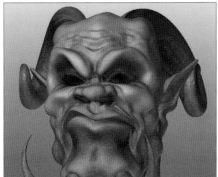

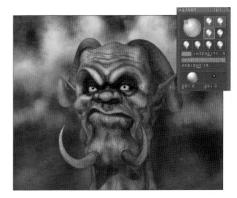

3 Once all the modeling is complete, it's time to think about texture and material. With Zbrush you can paint onto the model using the *Texture Master* script. This allows you to drop the model flat onto a canvas, paint on it with a range of 2D tools and brushes, and then pick it back up. To get it to map onto the head, the program uses UV coordinates, a method of telling a texture how and where to wrap onto a model. Most 3D packages support UV texture mapping in some way, making it easy to unwrap the texture from the head and edit it laid flat out.

4 To put a scene such as *Razareal the Painweaver* together, paint a large sky onto a canvas in the background layer. Next create three layers, placing the head on one and the horns and the eyes on the others. This really helps to keep the materials separate. Use a highly reflective and specular material for the eyeball, and a basic material with color bumps added for the skin. Any dark areas in the texture map on the head will show up as indented, similar to the bump mapping in a more conventional package.

5 The image was rendered with four lights all set up with different colors and effects, including the shadows that come from the left-hand side and the bluish glow from underneath. Using the render options it is also possible to add mist, depth of field, and blurring.

pixologic zbrush

artist glen southern **title** razareal the painweaver

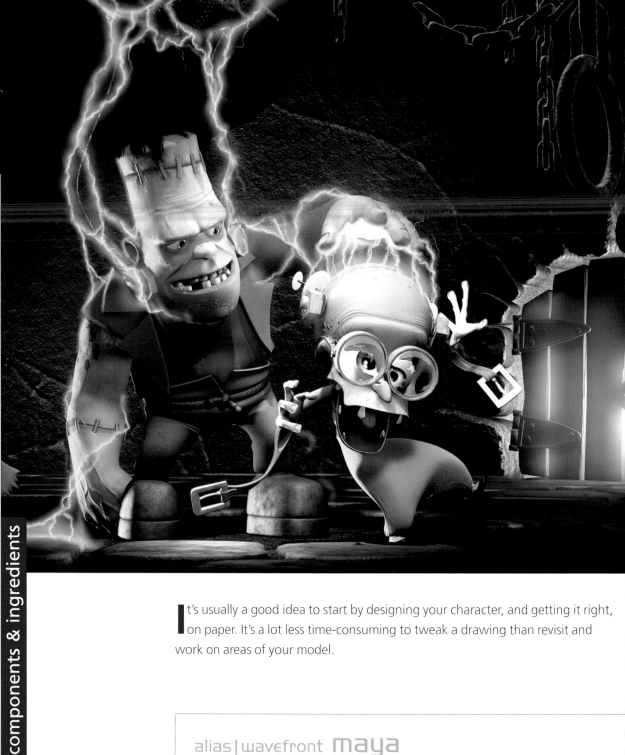

I t's usually a good idea to start by designing your character, and getting it right, on paper. It's a lot less time-consuming to tweak a drawing than revisit and work on areas of your model.

alias | wavefront maya

adobe photoshop

artists mark donald and david pate **title** frank'n'fhurter

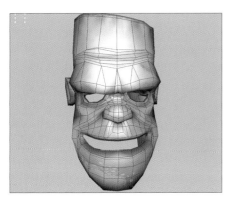

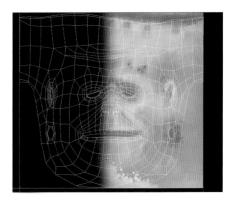

1 The modeling of character heads can be extremely satisfying. Learning how facial muscle structure works makes it much easier to create a more convincing head, whether it is realistic or exaggerated. When the face has all the polygons flowing in a direction similar to that of facial muscles, this makes creating facial expressions very easy indeed.

2 One way of creating a computer-generated model for rendering is to first build a low-polygon model, which is later smoothed before rendering. Using this method allows real-time manipulation of the model without having to deal with thousands of polygons on screen. You need to consider the positioning of the polygons very carefully. To keep a hard edge once smooth has been applied, you must have a series of edges very close to one another. It's a good idea to keep checking how the model is looking once it is smoothed, so you can see where edges need to be broken in order to keep the shape.

3 Texturing is probably the most time-consuming part of creating a computer-generated image, and can be very tedious to do if you are not enjoying it. Start by applying a cylindrical map to the polygons you want to texture. This creates a positional or UV map, which shows where the texture is applied to each polygon in the model. Once you've sorted out the UV positions in the *Texture Editor*, you can take a print of the screen and move into Photoshop, if this is the program in which you are going to paint. To do an area like the head, first paint a basic color map, which can be applied along with a solid fractal map by using a layered texture. Layered textures can add a lot to an otherwise dull texture, but is often better used as a base for the bump mapping. Creating a subtle fractal bump, and then overlaying specific detail, can give very natural effects without painstakingly painting each dimple of skin in a single image.

4 One way of doing the basic shading for a painting such as *Frank'n'Fhurter* is to use a Radiosity plug-in. Lights, such as rim and character lights, can be added on top. Once the characters have their lights in place, you can add others that affect only the background by using light-linking. This allows for extremely bright lights to be placed in the scene without any undesired effects being cast upon surfaces.

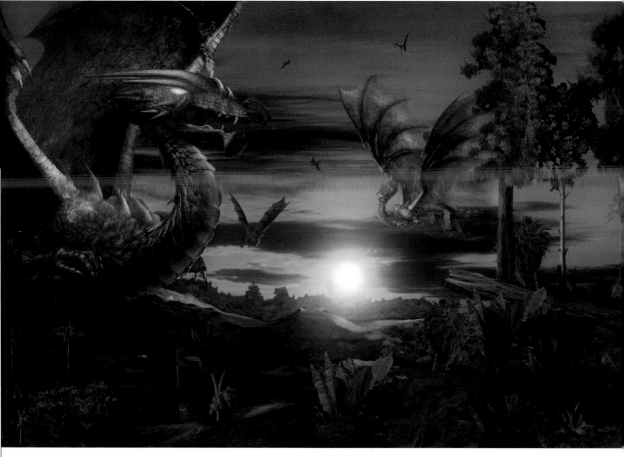

The dragon is one of the cornerstones of fantasy art. Legends telling of dragons are truly international, with these fabulous creatures being held responsible for earthquakes and volcanoes, as well as being symbols of power and majesty. The most familiar story, of course, is that of the dragon guarding a hoard of treasure, usually depicted as a great, scaly reptilian beast in a cave or similar subterranean environment. Several pieces of software lend themselves well to the creation of dragons, and whether it is the sketch and paint method of Painter or the full-blown form creation and skinning techniques of 3ds max, all are dependent in the end on the artist's imagination.

discreet **3ds max**

adobe **photoshop**

artist balazs-ward-kiss **title** when dragons fly

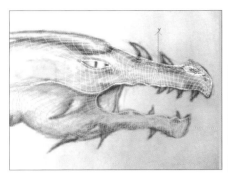

1 Modeling is one of the most time-consuming processes in digital art, but it can be made easier if you have an exact idea of what the final model looks like. Always draw sketches of the most important views of those elements you want to model. These pictures can then be used as reference images and placed in the background of the *Modeling Viewport* of 3ds max.

2 When modeling in 3ds max, the patch (surface) method is fast and easy. You first have to build the model base spline network and then apply the surface modifier to create the desired surface. This network consists of splines (or curves) making up the most resolved edges of the model, for example, the shape of the eye or the mouth of the dragon. The built in *Surface Modifier* creates a surface from the 3 or 4-sided spline networks.

3 You can initially paint the dragon's textures in Photoshop at a fairly high resolution. Smaller versions should be saved out in the same resolution as that of the final rendered image. To increase rendering speed, the image size of the textures should not be much larger than the size of the area in which they are to be rendered in the final picture. One advantage of using painted textures in this way is that you can emphasize important parts more easily and can also create more varied and combined textures. Bump and glossiness maps can be created in this way.

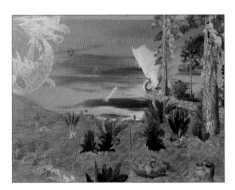

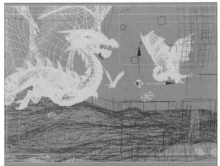

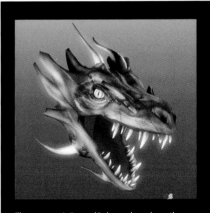

4 The trees and plants textures can be based on real photographs, which can also be used to create an *opacity mask*. This is a grayscale image that determines where the diffuse mapping textures are transparent.

5 Some artists like to use as many lights as possible. In *When Dragons Fly* the main lights (key light, fill light, and back light) dominate, and the supplementary lights have been used just to direct attention to small details. Of the six Omni lights used, some have the sole function of illumination or shadow casting. The sun was created with the built-in *Lens Effects* glow in 3ds max. For this, a red-yellow *Lens Effects* glow was connected to a standard Omni light. The same color glow was used on the dragons, which served to place them in the scene, and at the same time stand out from the picture.

The creature's "mood" depends on how the head looks, and for this reason it's a good idea to start the modeling process with this part of the anatomy. Different test renders with preview textures of the face/head can be used to focus on where to improve parts of the model.

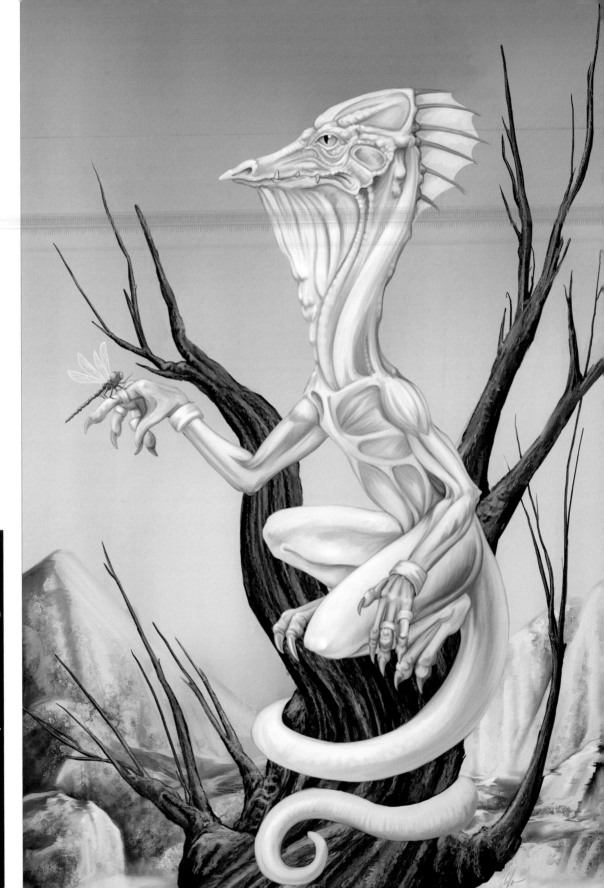

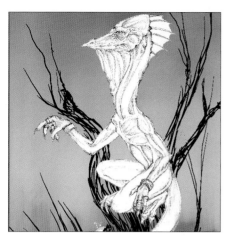

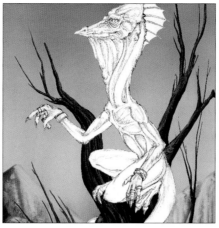

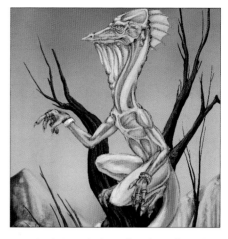

1 *Wingless* started out as some thumbnail sketches of the basic composition and layout, and a rough sketch of the dragon's head using pen and paper. A more elaborate final sketch of the dragon was scanned into Adobe Photoshop, where it was cleaned up, cut out, and placed on a separate layer. (Part of the tail, left out of the sketch, was drawn in, as was the tree.) Once you've got to this stage with your own image, you are ready to import the entire file into Painter.

2 You can rough in the background sky with *Watercolor* brushes and clean up the transitions using the *Airbrush* tool. Major features, such as mountains, can be painted in, and trees detailed and colored using the *Impressionist artist* tool. This gives a mottled bark texture to which shadows can be added using *Watercolor* tools. Apply texture variations with the *Palette Knife* tool.

3 Take the image back into Photoshop to flatten the layers. Next, use the *Simple Water* brush to lay down the base color of the dragon over the top of the sketch. Still working with wet *Watercolor* tools, use lighter colors to pick up highlights, and darker purple to block in—but not add detail to—the shadows, using the original sketch as a guideline.

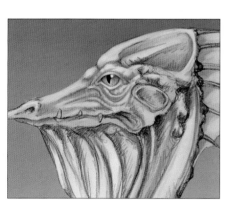

4 "Dry" the watercolor in Painter and begin work on the fine details, getting rid of the lines of the sketch, adding texture, and laying out light and shadow more solidly. (For this sort of smooth, sharp work, it's a good idea to use the round *Camelhair* brush with small strokes, and switch colors often.) Use the *Watercolor* tools for shadowed areas, drying them immediately afterward. On this closeup of the head in progress, note the difference between the smoother, shaded parts around the eye, and the rough areas where the original sketch shows through. Using small, circular strokes of a light color on a darker area gives an impression of scales.

5 As a final touch, add small items, such as the dragonfly, using the *Scratchboard* and round *Camelhair* brushes.

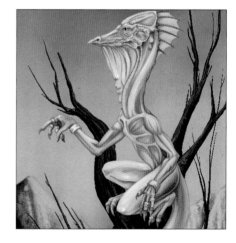

corel painter
adobe photoshop

artist ursula vernon **title** wingless

There is more than one way to skin a cat or, in this case, a dragon. 3D tools can be replaced by 2D-illustration software to create an alternative view of the royal beast of fantasy. Here, the use of Corel Painter gives a softer, more natural feel. Painter allows a faithful reproduction of the traditional artist's palette, but as it's in the digital world it has all the manipulative power of the computer, and attendant features such as undo, multiple saves, and a staggering range of media.

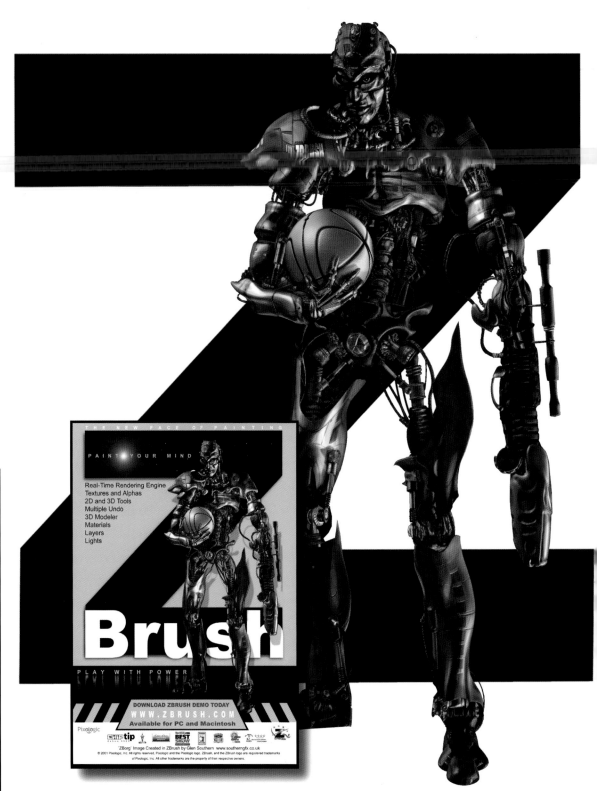

visions of the future: robots

components & ingredients

82

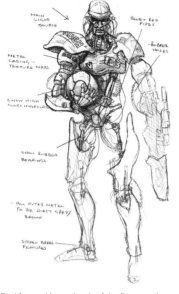

Robots come in all shapes and sizes, the most terrifying being those that emulate their human creators. *The Zborg* is a typical example of a machine engineered both to copy and supersede the human form. Using ZBrush to build *The Zborg* showed that the software is capable of creating detailed technical images as well as the more familiar organic creations. The initial step was to put pen to paper and sketch figures in different stances. The one finally selected had a very defiant pose, almost a superhero. Notes were jotted onto the final sketch about the materials, textures, and alpha maps that would be needed.

1 After making a sketch of the figure and scanning it in, it's a good idea to model and test-render some of the mechanical parts and their associated materials. For *The Zborg*, basic primitive shapes (or ZTools) were used in modeling the cogs, pipes, cylinders, hoses, shock absorbers, and the metal outer casings. These were then saved as custom ZTools in their own right. Another of the modeling tools in ZBrush is the masking facility. You can mask using imported alpha maps or directly in the software by painting a mask onto the object. It is possible to "inflate" the unmasked area, making it very easy to create intricate pieces.

2 Once you have created your own custom ZTools, do some test images. A range of metal materials and textures is needed for a "high-tech" look. The software provides a number of metallic materials, but in the case of *The Zborg*, none were suitable. Consequently, adjusting parameters in the modifiers panel created materials that would emulate brass, chrome, steel, and old metal.

3 To begin putting your robot together, import your initial sketch into a back layer and use it as a template to align the parts. You might, for example, start with the hips and work down onto the thighs. The sketch in the background will ensure that you don't get the proportions wrong as you add more and more intricate details.

4 Getting the hips and thigh joints to act as a pelvis, and the creation of two femurs, helps to make the robot's pose striking. If the test renders look fine for a particular area such as the hips, you are ready to go ahead with the main document.

pixologic **zbrush**

adobe **photoshop**

artist glen southern **title** the zborg

5 To give the robot a basic human outline, make the body casings look like parts of the human body. *The Zborg's* thigh casings were moulded out of basic tubes, and had spaces or holes to allow the viewer to see the shock absorbers and hoses. The body casings were then covered in textures created in Photoshop. To get a panel effect that could be used all over the body, some texture maps based on a gray/brown panel image were created and in places decals or numbers were added. Airbrushing dirt and scratches around the panel edges enhanced the metal look.

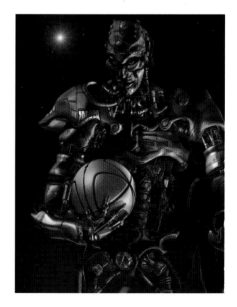

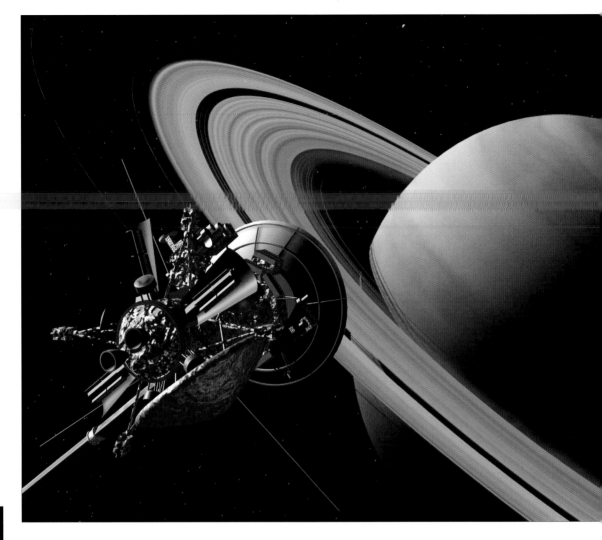

3ds max is a very useful tool for creating mechanical hardware due to its CAD-like interface and extensive primitive modeling tools. A good tip is to study real-life examples, even if you are intending to create a spacecraft of your own design. When modeling for realism, start with large structures and work down to the finer details. Use primitives to simplify the modeling task and model one detail at a time, working around the vehicle from top to bottom.

Robert Wankel based his model on NASA's Cassini Probe and found a wealth of data about this mission on the Internet at several NASA sites.

discreet 3ds max

artist robert wankel **title** cassini space probe

I Draw an orthogonal sketch of the probe to act as a blueprint. Scan the sketch and set this image as the reference background image. Be sure to lock the *Zoom/Pan* in the *Viewport Background* dialog box and use an orthogonal view (example *Left Viewport*). Using the *Line* tool, draw the profile as shown. Set initial line type to *Smooth* and the drag type to *Bezier* for the line creation settings. You can make 90° bends by triple clicking at the corners. Be sure the spline is closed and that the curves match the profile of the antenna dish in the background image.

2 Select the profile line you just created and click the Modify tab. Select *Lathe* from *Object-Space Modifiers* and you should see a 3D revolution of the curve. Now be sure to set the *Direction* as the Y-axis and to set the *Align* to max. Set the *Degrees* to 360 and the mesh segments to 50.

3 Next add some gusset plates to support the dish. Using the *Line* tool, draw the profile and extrude to give it some thickness. Then locate the plate in position and using the *Array* function, copy it 12 times, letting 3ds max do the rest of the work for you. The same *Array* function is used for the support brackets for the dish collector details.

4 Create a chamfered cylinder in the top viewport and size it to match the background image. You want to create the illusion of a mylar foil covering, so in addition to applying a foil material map to the body, apply a noise modifier to the geometry. Play with the values until you make the surface smooth but wavy. Use the N-gon primitive to model the top half of the probe. Set the sides to 12 and adjust the scale of the length, width and height to match your reference image.

5 The two fuel tanks are easily modeled using the sphere and capsule primitives. Once you have created them, move them into position and adjust the dimensions as needed. You may also want to create spars and brackets to support them by positioning long thin cylinders. Remember to use *Mirror* and *Clone* to simplify the tasks. Creating details can get tedious but it will be worth the effort.

To create the rocket nozzles use the *Lathe* function again. First draw the profile using the *Bezier Line* tool, and after using the *Lathe* function, clone to create the second nozzle. Keep adding detail using primitives until complete, then add textures. Experiment with materials as not all surfaces need be covered in foil. Some detail might be lost if you use the same material over and over again.

6 The planet Saturn was modeled using astronomical data, with an image map for the planet's globe created in Photoshop using NASA images as reference. The star background was an environment map created in Photoshop. Lighting was provided by one key light and two low-intensity fills, all approximately 120° apart. 3ds max's *Scanline Renderer* with lights set to *Shadow Map* was used to render the image—with the background image of Saturn rendered first and then the probe composited over it.

The worlds created by fantasy artists are incredibly various, ranging from scenes of breathtaking beauty and elegance to those of the darkest nightmares. It is a measure of the artist's talent that such images are frequently highly realistic and evoke strong feelings in the viewer, whether it be comfort, humor, unease, or even disgust.

Even the most detailed image of a fearsome dragon or tough space marine needs a setting, and it is often the attention paid to creating the landscapes and background detail of a picture that turns it into great fantasy art. The reverse is also true, and careless setting has ruined many a good picture.

Help is at hand, though. The following pages will show how the background elements of fantasy painting are constructed, how water and skylines add to the mood of a picture, what strange and curious architecture can be built, and how complete worlds can be created by a talented artist.

section three

environments of the imagination

artist david ho title the future of war

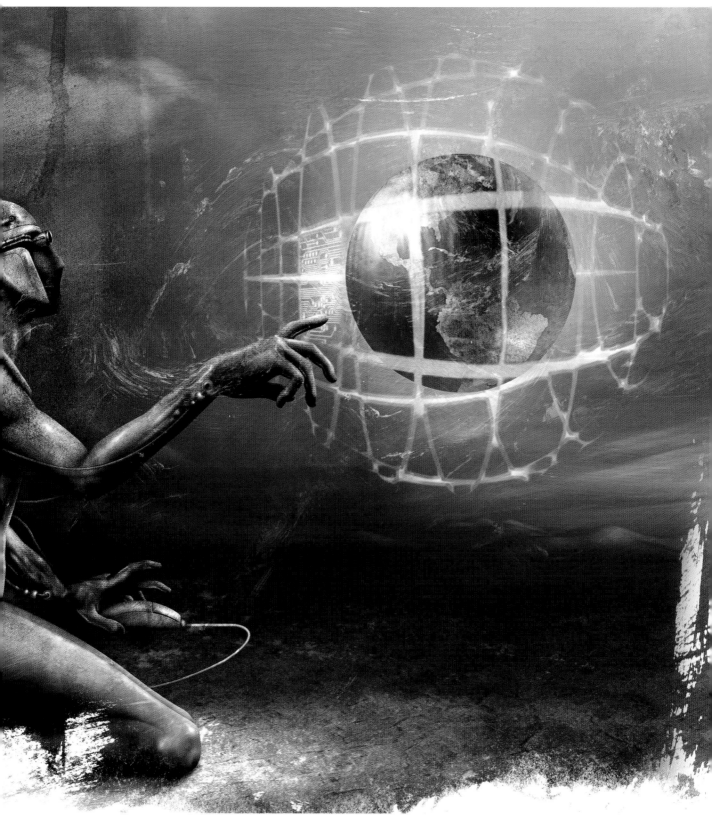

Bryce is excellent for creating landscape scenes. Realistic recreations of the natural world or flights of fancy are all possible in this program and others like it. A good initial step is to do some sketches of the desired scene with pencil on paper. From this you will be ready to start constructing the picture. Here the focus is on using Bryce, but the general points on creating landscapes apply to other applications of this kind.

coɾel **bɾyce**

artist slawek wojtowicz **title** sunny delight

88

Sky Preset 393

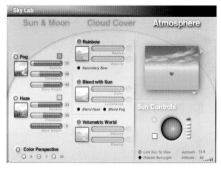

After opening Bryce, you are presented with a basic blank scene, showing the three-dimensional space where you will be working. Bryce ships with preset values for most of the major elements of a scene, so start by picking the sky preset you would like to use for the image (select from the *Sky & Fog* menu above the image).

The preset can be modified to match your needs using *Sky Lab*. Select the *Sky & Fog* function above the image, then click the *Sky & Fog* options arrow on the far right—next to the *Sun Controls* ball—and select *Sky Lab* from the menu. Within *Sky Lab* select *Atmosphere* and adjust the values as shown here.

thin clouds

The resulting image produces a water-like effect without actually using a water texture, but it will look more realistic if there is a suggestion of shallows in some places. To achieve that effect, add another textured layer to the water plane—in this case one of the cloud textures. This can be found by selecting *Edit* and then by selecting *Materials > **Cloud and Fogs***.

rocky

Now it's time to create the rocks. After picking one of the presets from the *Create* menu, go to *Mountains* and select a desired terrain shape. That shape can be modified in the following way: go to *Edit* then click on the *Terrain/Object* icon (the last icon on the right over the image). When you are happy with the shape of the rocks, select their texture. Go again to the *Edit* function and click on the adjacent small arrow to reveal texture presets. Then simply select a desired texture. (Note that the same texture can vary in appearance depending on the lighting.)

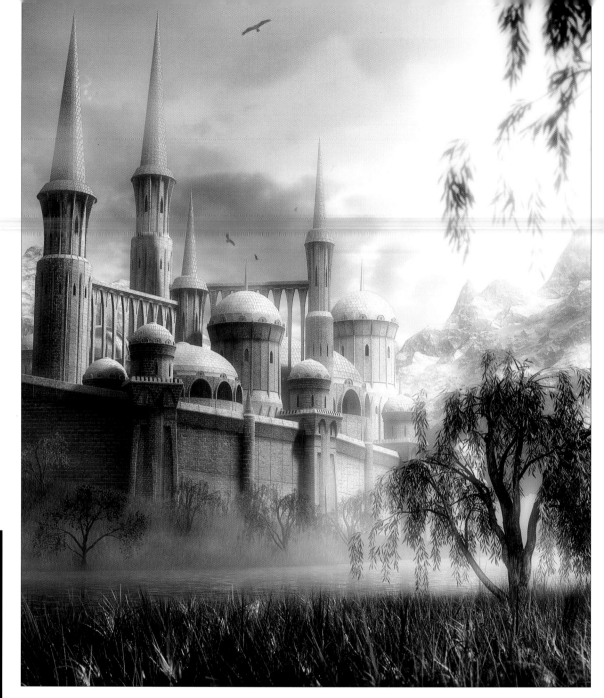

Dragon's Keep was created for the cover of the music CD of the same name by Medwyn Goodall. The goal was to create a fairytale fantasy scene, with a light and airy feeling about it, to go with the music. To this end, it was decided that the castle would have thin long towers and big domes.

1 The first step is to create a very rough castle object as a draft in Lightwave's *Modeler* component, then a more detailed version using *Modeler*'s special tools and operations. For *Dragon's Keep*, the castle towers were modeled using simple primitives—cylinders, spheres, and cubes. Boolean operations were used to drill windows and other elements where needed. After the draft tower shapes had been created, *Modeler*'s *Bevel* tool was used to subdivide the geometry and bevel some polygons here and there, so that the towers look like they are made out of separate panels. The *Bevel* tool can be accessed from the *Multiply* menu in *Modeler*, or by pressing the "B" key on your keyboard.

2 One way of texturing the tower models is to use DarkTree to create a non-repeating brick pattern with a high resolution, suitable even for extreme close-ups. Running a few closeup test renders will help you make sure the textures look right. Once you have done this, you are ready to arrange the tower models in the final castle complex in Lightwave's *Layout* mode. In *Dragon's Keep*, the complete castle model consists of 85,000 polygons.

3 The mountains in *Dragon's Keep* were created with a simple subdivided plane to which a *Turbulence* displacement texture was applied. It was then textured with different layers of procedural noise, and with a slope-based snow layer. This takes advantage of a more recent feature in Lightwave where the gradient of the surface can be adjusted to change the appearance of the texture.

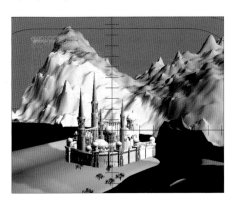

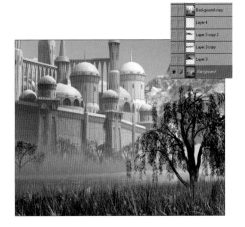

4 In *Dragon's Keep* the lighting consists of two parts—one for the castle and one for the foreground trees and grass plane. Every one of these has its own "sun" and skylight. Splitting the lighting setup in this way allows precise control over how the most important elements of the scene are lit. The castle part of the lighting setup features a cluster with 10 spotlights simulating the skylight and a sun spotlight. The foreground part has its own sun spotlight and two spots for the skylight. Each part of the lighting setup has been tweaked to look more interesting—the direction of the "sun" slightly differs for each part.

5 The tree objects were made using Tree Professional and then imported into Lightwave's *Modeler* for corrections. The grass was created using the Sasquatch rendering plug-in for Lightwave. This plug-in can render millions of grass blades without using expensive geometry. The final image was rendered at a print resolution with a solid, color sky. This had an alpha value of 0, because the next stage was to take it into Photoshop and mix it with a digital photo of the real sky. The top-right tree branch was also rendered separately. Composing and then blurring it slightly in Photoshop created a slight depth-of-field effect. The final touch was to add some flying birds in Photoshop.

newtek **lightwave 3D,**
adobe **photoshop,** darkling simulations
darktree, onyx computing **tree**
professional, worley labs **sasquatch**

artist dimitry savinoff **title** dragon's keep

water, terrain, and skies

environments of the imagination

The fantasy landscape of *Hall Of Beginnings* was created for the Tony O'Connor music CD of the same name. The aim was to create a mystical and heroic-looking castle scene, with plenty of deep colors and atmosphere.

1 Begin by constructing a castle object in a similar fashion to the example on pages 92–93. For *Hall Of Beginnings*, the structure consisted of 84,000 polygons.

To create the visually non-repeating brick pattern for the castle surface, you can use a procedural texture made with DarkTree.

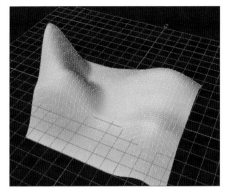

2 Lightwave's *Modeler* can be used to create the rocks on which the castle is built, with a turbulence displacement map applied to the rough object to get a rugged look. To give an even more jagged appearance to the rocks' surface, you can add some procedural texture layers to the bump and color surface channels.

3 The water in *Hall of Beginnings* is a single polygon object with three layers of procedural noise on the bump channel. You can apply a *Fresnel* effect to increase reflectivity as the angle between the viewer and the water's surface gets bigger. Do this by creating a gradient on the reflectivity surface channel, with the incidence angle as the input parameter.

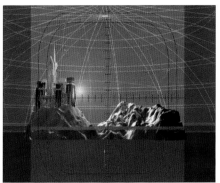

4 One way of creating the sky is to surround the scene with two semi-spheres mapped with fractal noise. In order to get a more interesting sky pattern that looks less computer-generated, take a digital photo of the sky with a camera. Then overlay the photo on the fractal sky rendered in Lightwave, using the alpha mask that can be rendered with the image.

5 The foreground, with grass and bushes, can be rendered separately and then composed in Photoshop to allow greater control. You can quickly achieve the depth of field effect by blurring the foreground layer a little bit. Final touches to scene—such as the fog line painted over the water and the boosted sun halo—can also be added in Photoshop.

newtek lightwave 3D, adobe photoshop, darkling simulations darktree

artist dimitry savinoff **title** hall of beginnings

Often the background of a painting can express as much feeling as the figures in the foreground. Consequently, it's important to be able to paint scenery that is both recognizable and emotionally gripping. One often neglected (but very important) part of any outdoor scene is the sky. Depending on the colors, lighting, and brushstrokes the artist uses, a sky can create any mood at all, from peaceful to oppressive.

painting the sky

environments of the imagination

The first thing to do is pick a palette, bearing in mind that the colors you choose are going to affect the mood of your picture. Here you can see that deep, grayish purples and pale yellowish greens have been chosen as the main colors. The fact that purple and yellow are on opposite sides of the color wheel will help create the illusion of depth without going overboard on clashing complementary colors. Use the *Paintbrush* and *Eraser* tools to sketch out the scene in rough brushstrokes and get a feel for what's going to go where. It's a good idea to stay away from the *Fill* and *Gradient Fill* tools as much as possible as they give very flat effects.

2 The intention in this image is for the clouds to sparkle like pink champagne and sweep diagonally up the sky (a painting is not reality). To get the sparkling effect, sharp, brilliant yellowish-white highlights, and shadows in a richer purple, are added. For the small, hard strokes at the very edges of the clouds, the *Paintbrush* tool with a soft-edged brush is used. For the larger, form-defining strokes, the *Airbrush* set to a soft brush and a low (about 30%) transparency is more suitable. One hint: avoid pure black or white. Even in the brightest and darkest areas, always have at least a subtle hint of color. This will not only make your paintings more interesting, but make them look better in print as well.

3 The skyline consists of a jagged, stylized mountain range. Since the mountains have a more blocky, defined shape than the clouds, a slightly different technique is used to paint them. This consists of first painting in the hard, heavy blocks of light and dark with the *Paintbrush* tool, deciding where the highlights and shadows will fall. Then slowly refine the mountain range by painting in soft gradations of deep purple, subtle green, and bright pink and yellow, always keeping to your original lighting scheme. To give further direction to the light, use a lot of diagonal brushstrokes in the same direction as the light source. To prevent the foreground of the landscape from distracting the eye from the dramatic skyline, keep it very simple. Ripples of ice are suggested with minimal horizontal brushstrokes.

4 The Photoshop equivalent of adding a wash of paint is done to counteract the effect of the deep, bright purples that are threatening to overpower the border. The *Image > Adjust > Color Balance* menu is used to increase the blues in the shadows, and the *Image > Adjust > Brightness/Contrast* menu to lighten the whole background slightly and decrease the contrast. These menus are very useful for quick color adjustments, but they have the disadvantage that they are applied equally to the whole picture. You cannot suddenly decide to paint a sweeping arc of lighter colors in one corner of the canvas, and leave the rest relatively untouched, while sliding the controls about on a menu.

In the final version of the image (see opposite), the clouds are used to create a sense of motion and excitement in an otherwise very static composition. It's important to view the background as an essential element of the whole, not simply something you insert behind your figures. The lighting and color of your sky should affect every element of the finished picture.

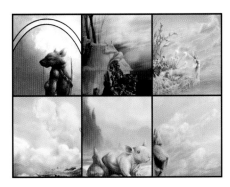

Additional tips

By varying the colors, the weight of the clouds, and the contrast between the sky and the rest of the skyline, you can achieve an enormous range of moods and effects. Here are several smaller shots of how different skies could be done. From left to right, top to bottom: a "wererat" warrior standing beneath the scorching afternoon sun; a sad, pensive scene with a knight on his horse; fairies sailing through the warm morning mist; a summer's evening sky; a cold, gray day and an unhappy rat; and a bright, sunny afternoon.

adobe photoshop

artist socar myles **title** clouds

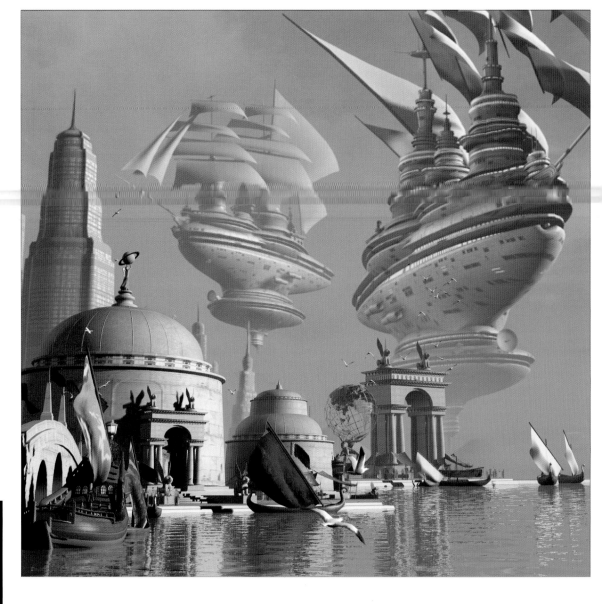

Starting with a sketch or several sketches that set the basic scope of the picture, one way of working with computer-generated landscapes, or artwork in general, is to move from the back toward the front, creating and placing objects as you go.

discreet 3ds max

artist by jerry potts title argon

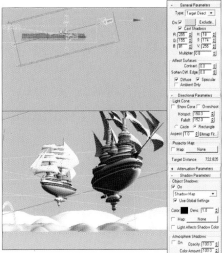

1 The hills and mountains in the distance are the first objects to be created. These are made from a plane object with 50 horizontal and 50 vertical divisions. Apply a displacement modifier with a good displacement map loaded. The displacement map is usually a two-tone image in which the lighter areas will be the raised areas on the plane. The finished plane can be cloned, then enlarged and rotated to create a series of mountains and hills. Choose a picture of a sky or paint one yourself and load it as the *Render > Environment > Background Image*.

2 A complicated model, such as the air ship seen in *Argon*, is often best created in a separate max file. It helps to have an uncluttered area to work in when modeling. The finished model can then be imported by merging (under the *File* tab) the airship.max file with the landscape.max scene.

Once a few objects have been created, you are ready to create the lights. For outdoor scenes, try creating a number of lights from all angles. In *Argon,* blue-gray lights create the ambient color and a warm pale yellow light represents the sun. All of the lights are of the direct target type. The blue-gray lights will have shadows turned off with a multiplier of between 0.5 and 0.8. The sunlight (warm pale yellow) should have shadows turned on and a multiplier of at least 1. During this stage it's a good idea to make several test renders, carefully adjusting the various lights, their multiplier, color, and angle until the objects are illuminated to your satisfaction.

3 Once you are satisfied with the lighting, move on to atmosphere. Atmosphere is very important for giving any landscape with distant objects that look of reality. Under *Render > Environment* you will find *Volume Fog,* which works best for creating the air and moisture that help make distant objects fade away. First create an atmosphere box gizmo large enough to include all distant objects, then include that box gizmo in *Volume Fog*. As with lighting, much adjustment and test rendering will be required. For the *Argon* scene, the settings that worked best were: **Soften Edges**: 0.56; **Density**: 0.8; **Step Size**: 4.0; **Max Steps**: 10.0; **Noise Uniformity**: close to 1.0; **Fog Background**: checked.

4 Now that the lighting and atmosphere is complete, the foreground objects can be created and positioned to complete the image envisaged in the original sketch.

Digital artwork, as you will have already discovered, is rarely created and completed in one package alone. It is often the case, especially when using 3D software, that components of a scene have been created using several software applications and then composited together into a finished piece of art. In the following pages, artists demonstrate how they tackle the process of bringing all these scene elements together and how they blend them into a composite whole. For each stage the best tool available for the job has been used, whether it is to model a character, apply lighting and texture, or merely "tweak" the components so that they blend more smoothly together.

As in previous sections, each of the main images is accompanied by a series of scenes showing the key stages in its creation. However, there is more emphasis on the different software applications used for each major stage, with notes on why the artist used a particular package and technique, and any problems they encountered. The final images in this section are a little different from their predecessors in that they demonstrate some of the alternative uses for fantasy art, along with creating backgrounds for video games and matte paintings for science fiction and fantasy films.

section four
bringing it all in

artist molly barr title midnite sun

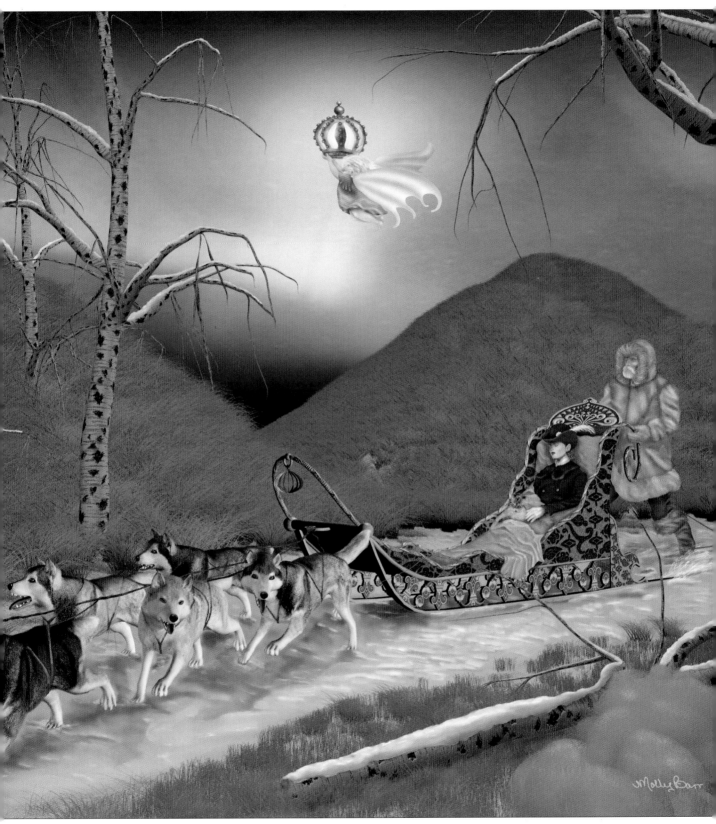

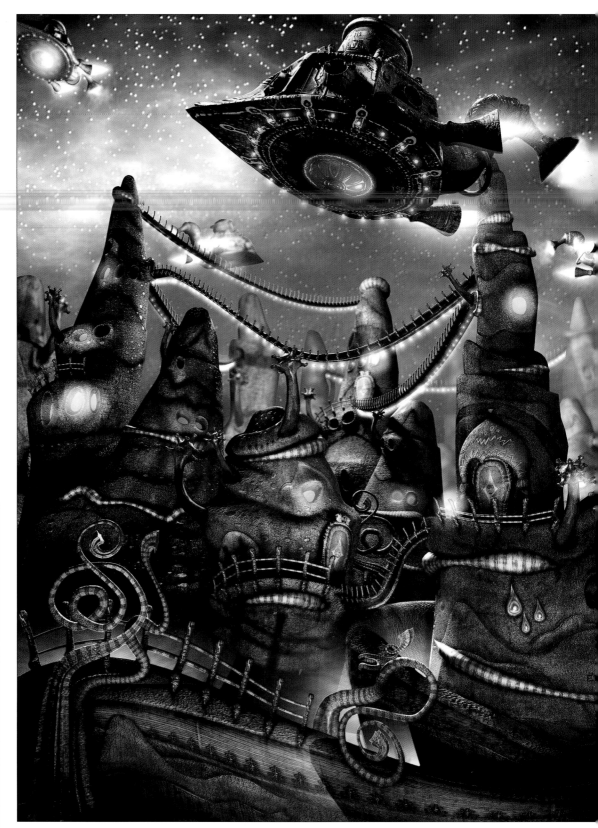

Most of the elements in a painting such *as Little Village Far, Far Away* can be modeled in 3D using a method called "box modeling," where a simple polygonal model is created by pushing, pulling, and extruding vertices and faces to form a basic skeleton. In the painting, the spaceship represents a young person who leaves the comfort of his or her home town in search of other worlds.

2 Once the skeleton of an object is complete, you can export it from Nendo and import it into 3ds max. Applying a *MeshSmooth* modifier will smooth out the vertices. In the spaceship, some of the square-looking faces turn into rounded windows and the entire object acquires a more organic looking form.

1 This sequence of three steps shows how the spaceship structure is modeled using Nendo. This method is also available in 3ds max, but Nendo is a quick little package that is easy to use. You can manipulate, divide, or extrude the different elements of a model (vertex, edge, face) to make the object more complex. The example shows how manipulating a simple, lathed object creates the spaceship. To form the windows, the faces are cut, and divided and extruded. To form the tail, the back faces are extruded several times, while rotating to form the curve.

3 The odd-looking plants, which pop out of the building's windows, are made by extruding the faces of a simple box, while rotating at the same time to form the curved stem. Extruding several of the faces at the same time makes the top crown. The buildings are made by manipulating the faces of a lathed cylindrical object and then dividing and extruding some of the faces to form windows. All these elements are imported into 3ds max and placed together to form the start of a composition. The buildings are placed in the foreground.

nichimen **nendo,** discreet **3ds max,**
cebas **pyrocluster,** adobe **photoshop,**
corel **painter**

artist eni oken **title** little village far, far away

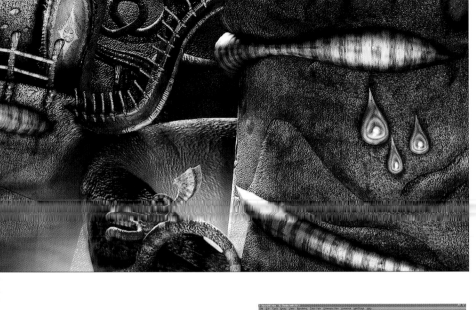

Material properties are assigned to the models of the "little village;" then 3ds max and painting programs such as Adobe Photoshop and Corel Painter are used to create a bit more detail, including strange plants and weird architecture.

alien worlds (2)

bringing it all in

4 Each model receives a material (shader) created in the *Materials Editor* in 3ds max. The materials for the buildings are of Mix type, where two maps, in this case a colored painted texture and a distress map, are combined to form an amalgam. The colored maps are custom-made for each model, with features enhancing the model and adding more intricacy. In the image shown here, Painter's natural brushes are used to create the painterly overall dappled colors, while Photoshop is used to manipulate layers and add drop shadows. These overlapping elements with drop shadows simulate a "dimensionality" that is not really there.

5 Other geometry is added to the original buildings, such as odd-shaped plants coming out of windows, striped worms crawling along the surfaces, and patios with railings and fake doors. Each one of the buildings goes through the same process as before, receiving materials with custom-made painted textures and extra-modeled details. Some of those details, such as the bridge, connect two buildings, integrating them together. Creating a series of smaller vertical elements spaced out and connected with a cylindrical tube makes the patios with rails.

6 The curly elements found in the foreground are made by lofting a star-shaped profile. (Lofting is a way of creating an extruded surface.) The path is a curvy spline: at the very bottom of the path the profile is larger and then slowly reduces its size while traveling along the path. The mapping coordinates are applied within the lofting parameters so that the texture map can follow the curves of the path. The texture map is painted with stripes with a darker bottom so that the model is integrated into the shadows of the base. The top of the texture is painted bright orange. Three of these lofted models are created for this scene, with different paths, using the same texture map.

7 Other buildings are created and placed in the scene. To balance out the strong buildings on the right side, a tall building is placed on the left, slightly behind the middle one. Copies of these buildings are created, rotated to seem different, and placed in the background, spaced out. A camera view for the final rendering is created in order to assess the exact location of the new buildings and help in the blocking and placement of all the elements. The top view shows how the background buildings are very distant from the front group, although in the final composition they seem close by.

8 With the final camera locked in place, it becomes easier to place other elements of the scene, such as the connecting bridges between the different buildings, and the three spaceships, one larger in the foreground and two smaller ones in the background. The lighting is also worked in: groups of buildings are treated together and lit using a three-point lighting scheme, with a key light, filler light, and backlight. Most of these lights receive attenuation, which is the ability to fade out after a given distance, so limiting the scope of each lighting group to specific objects.

9 For the final touch, fog and effects are applied to the scene. A backdrop is painted with some distant stars. The flares, smoke, and starbursts are created using the Cebas Pyrocluster plug-in for 3ds max. This plug-in works with the aid of "helpers," each of which represents the location of a flare or smoke. The image shows all the helpers and flares created for this scene. The interesting thing about using helpers for these effects, instead of post-production painting, is that the flares can be positioned in 3D space behind certain geometry. This allows for specific flares to shine partially from the inside of the exhaust of a spaceship or seem to come from underneath the buildings, shining upwards.

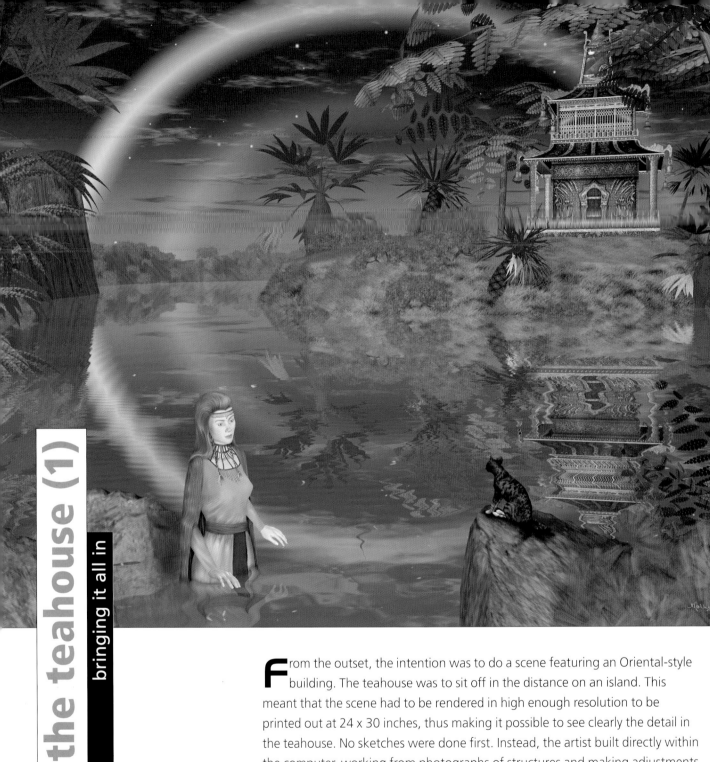

the teahouse (1)

bringing it all in

From the outset, the intention was to do a scene featuring an Oriental-style building. The teahouse was to sit off in the distance on an island. This meant that the scene had to be rendered in high enough resolution to be printed out at 24 x 30 inches, thus making it possible to see clearly the detail in the teahouse. No sketches were done first. Instead, the artist built directly within the computer, working from photographs of structures and making adjustments to give the final building a fantasy feel.

I Working in 3ds max, you can start to create a building like the teahouse by using blocks (or box primitives), shown here. One box, for example, is placed for the foundation, one for the lower section below the roof, one for the midsection, one for the top section, and so on. Then their height and dimensions are adjusted until the proportions are correct. Building from the ground up, you can then begin to replace the boxes with more detailed elements, texturing them—with texture maps custom-made in Photoshop—as the building takes shape. The foundation is divided up into a couple of boxes and the ornate fence constructed in sections, then repeated around the top of the foundation.

Next, the lower section is built on top of the foundation. The front and side walls need to be in separate pieces, rather than one solid box, if they are to have different texture maps. This means deleting the initial placement box and constructing the four walls on the foundation, along with the columns, bells, and bell supports. The roof is a four-sided, hollow cylinder that is tapered and curved. Again, similar sections of the lower fence are duplicated and placed on top of the roof.

The upper sections are then built on top: a square room, the second roof, a tapered room, and the cone to top it off. The bells and supports of the lower section are duplicated and resized to decorate the second roof. The two rooms are solid boxes (i.e. not four walls), since the texture is the same on all sides, and it isn't necessary to see inside the room.

2 Shown here are a few of the texture maps created for the teahouse. Notice how a texture map can give the illusion of dimension, and even doorways and windows. The same procedure was used for the textures throughout the building. The door and doorframe are not modeled, but instead are painted on a two-

dimensional texture map in Photoshop. Layers are used in Photoshop with shadows added beneath elements to give them depth. This process works well for camera angles that are "straight-on," but not as well for more angled shots.

3 The tea house is now a complete, three-dimensional model that can be rotated and resized as necessary, and is ready to go into a scene created in World Builder.

World Builder renders scenes in an object-by-object fashion, but allows you to stop at increments, make additions to the scene then continue. So it's good planning to build the scene in layers from the background up, perhaps starting with the sky, then moving on to the topography, and finally the textures and foliage.

4 Here is a World Builder scene in progress. The basic landscape has been created, the sky rendered, the ground textured, and there are a few plants applied, but no water. It is now ready to be exported into 3ds max.

discreet **3ds max,**
animatek **world builder pro,**
adobe **photoshop** curious labs **poser**

artist molly barr title the teahouse

5 Here the World Builder landscape has been imported into 3ds max, with a blank water plane included. *World Builder's Camera* has also been imported so that the camera angles will match in both programs. Later, the same can be done for some of the lights, allowing 3ds max objects to cast shadows on the World Builder landscape in the final render. This can take many adjustments in both programs to bring the two scenes together properly.

The lady and cat have been posed and imported from Poser into 3ds max. Poser 4 Pro Pack has a plug-in for 3ds max that allows you to create your characters in Poser and update them easily in 3ds max. This works very nicely, and also allows the textures that come with the Poser figures to map correctly. (A similar plug-in is also available for World Builder, but you may find that the texturing works better in 3ds max.) Notice that the woman is fully textured, but has no clothing or hair, as that will be added by hand in Photoshop after the final render. Poser provides a selection of hair and clothing, but you may prefer the greater versatility of painting them yourself.

Once imported into 3ds max, the landscape can be used as a guide for placing the objects. It is possible to import objects from 3ds max into World Builder, but the transition often does not work with complicated structures, and the textures don't always transfer correctly. An alternative is to use the 3ds max Communicator plug-in for World Builder, which allows the two programs to interface together and render the two scenes as one.

6 Here is the completed 3ds max scene, ready to render with the World Builder scene at right. When the placement of all of the 3ds max objects is correct, the landscape is deleted from 3ds max, and the 3ds max scene will look like the scene above, with the objects floating in black space.

7 Back in World Builder, the scene is completed as shown here, with all of the plants and so on. World Builder has an impressive array of textures for the landscape and flora. However, it is easy to manipulate them if, for example, you would like to make a red palm tree.

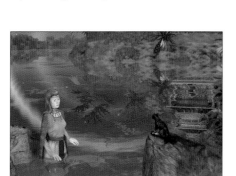

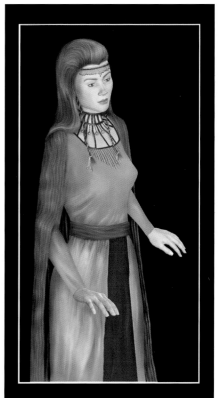

8 The communication between the two programs is now set up, and the render started. The scene can be rendered either in 3ds max or World Builder. However, there are advantages to running the render in World Builder as far as lighting and shadows are concerned. When the two scenes are rendered together they look like the detail of the scene shown here except that the lady is nude and bald. Notice that since the costume was not part of the render, any effect it has on the environment (i.e. shadows, reflections, etc.) will not show up—these touches need to be added by hand, post-render, in Photoshop. In this scene a reflection of her costume is added to the water.

 The Tea House was rendered at 7800 x 6240 pixels, or 260 dpi, at 24 x 30 in. Doing a dual 3ds max/World Builder render at resolutions as high as this one can be a frustrating experience, and take 24–36 hours, if it renders at all.

The lady of the teahouse
With the final render accomplished, the image can be taken into Photoshop for the post-render work. In this case, it's the lady of the teahouse. To create costumes with this kind of detail, a high resolution is required so that there are plenty of pixels to work with; also a graphics tablet, such as a pressure-sensitive Intuos Wacom tablet, is highly recommended. The post-render painting of hair and costumes, and perhaps dragons or other creatures, is often as time-consuming as building the scene itself.

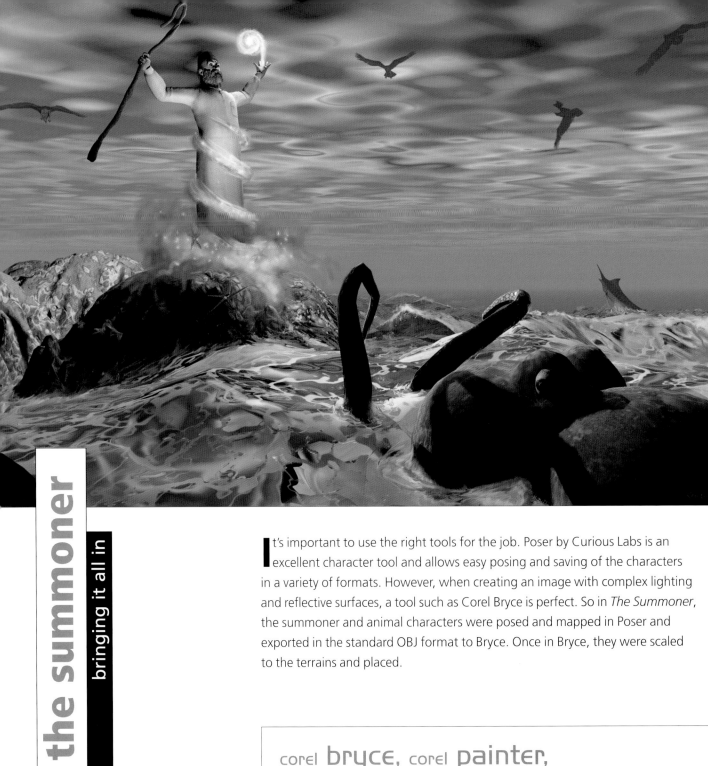

It's important to use the right tools for the job. Poser by Curious Labs is an excellent character tool and allows easy posing and saving of the characters in a variety of formats. However, when creating an image with complex lighting and reflective surfaces, a tool such as Corel Bryce is perfect. So in *The Summoner*, the summoner and animal characters were posed and mapped in Poser and exported in the standard OBJ format to Bryce. Once in Bryce, they were scaled to the terrains and placed.

corel **bryce**, corel **painter**, curious labs **poser**

artist ken gilliland **title** the summoner

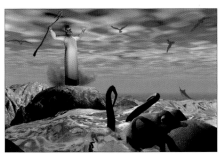

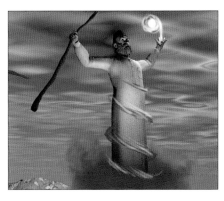

1 In the Bryce layout, numerous spheres are textured with a smoke texture. Three lights are used for dramatic effects. All have a soft focus and are muted to between 10 and 20 points. The sphere light (called the *Magic Light* here) lights the head, hands, and shoulders, while the two cone lights light the base of the figure, the smoke puffs, and the octopus. A terrain rather than a water plane is used to simulate the rough seas, with a dip being created via the terrain editor to place the octopus.

2 Unfortunately, the magic smoke puffs do not render well, so this is the first item on the post-production list. The base smoke color is better and so is used as the base color in the magic smoke. Also on the list are sea foam, splashes, and water on the rocks and creatures.

3 The smoke can be greatly improved in Painter. The smoke color can be picked up with the *Dropper* tools. Using the *Oil Pastel* tool with about 30% opacity, the structure for the magic smoke is drawn. Next, using the *Grainy Water* brush, the smoke structure is brushed in a 45% angle upward, slightly blending it with the sky and figure. A lighter hue of the smoke color is added with the *Artist Pastel Chalk* brush, and the smoke effect is built with the *Grainy Water* brush. Using the *FX Fairy Dust* brush adds a bit of magic to the magic smoke.

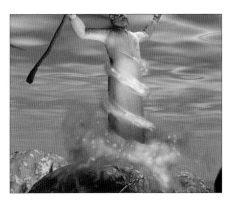

4 Once the smoke starts to look pretty good, the starfish can be outlined, copied, and pasted in several distorted versions at 50% opacity in the magic smoke. This adds a little more variety to the smoke.

5 Work can now start on the water using the *Artist Pastel Chalk* tool at a low opacity to add crests to the waves and foam splashes to the rocks. Loosely drawing lines to mirror the rock shapes, subtle colors are introduced into the rocks to give the appearance of moisture. The lines are then softened using the *Grainy Water* brush and the *Distorto* brush from *Liquid*.

6 A series of lines are placed with the *Pastel Chalk* brush where the octopus and the water meet, to simulate the octopus rising from the depths. Again, the lines are softened with the *Grainy Water* and *Distorto* brushes. Splashes are added around the body and tentacles, and slight hints of the ocean color are added to the top of the head and tentacles to blend the octopus with the sea and lose some of the hard edges. This method is also employed on the marlin. Finally, the raptor's wings are slightly motion blurred to give the illusion of flight.

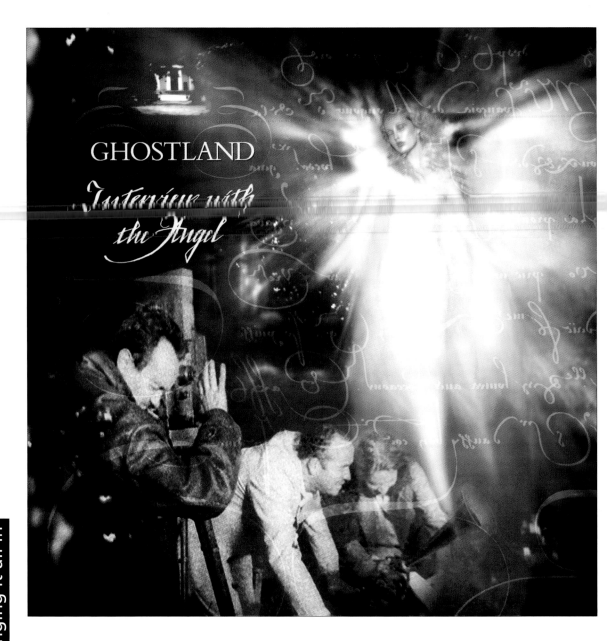

V-On Ltd. commissioned Tony Stiles to design the cover for the *Interview with the Angel* CD by Ghostland. This is a good example of "bringing it all in:" compositing elements of an image from different sources, mediums and, in this case, different artists to create a new piece of album cover art. The starting point was a short film, directed by David Scheinmann, based on some mysterious 1920s' footage, which appears to capture the appearance of an angel. This old film was the inspiration behind the recording of the album and so would become the focus of the album cover. The brief was to recreate the scene of the apparition in one single image.

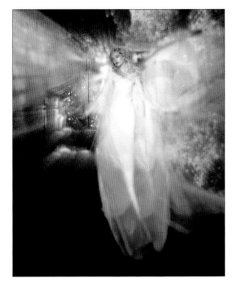

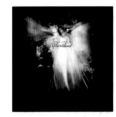

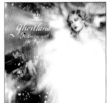

3 A black-and-white photograph was scanned in and cropped in Photoshop. Setting its layer to *Screen* meant only the highlights would show. Using *Replace Color*, clicking in the black area and adjusting the *Fuzziness* enabled accurate adjustments of those parts of the image that would show. The image was then colored with the *Colorize* feature from *Hue/Saturation*, to create a duotone.

1 To get the atmospheric look required, the photographic image of the angel was copied onto many layers in Photoshop, each with different *Gaussian* and *Zoom* blur values, generally in increments of 1, 2, or 5. Each layer was then switched to *Soft Light*, *Overlay*, *Hard Light*, *Darken*, or *Light*. This enabled the layers to interact with each other, creating a variety of differing effects. By adjusting *Brightness* and *Contrast*, *Hue/Saturation*, *Levels* and the *Opacity* of each individual layer, it is possible to have complete control over the tiniest of variations. By erasing parts of each layer, you can gradually build together all the best sections.

2 For the group shot of Ghostland, a still was taken from a master Beta SP tape of the band video. Various frames were grabbed at 1200 dpi and copied onto a DVD RAM disk, along with a lower–resolution copy of the whole film for reference. These stills were very grainy, so to get around this problem the layer was duplicated, with the top layer set to *Hard Light*. Some *Gaussian Blur* was applied to the bottom layer to soften the grain. Touches of *Brightness* and *Contrast* and *Levels* were used to bring out the highlights. The group then had to be cut out of the background using the *Eraser* and *Stamp* tools. It's preferable to use these and actually erase rather than use a mask. It's also helpful to use an A3 graphics table and pen, as using a mouse is like drawing with a bar of soap!

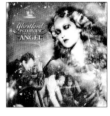

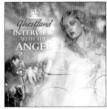

4 Instead of using an existing font for the type, Gabrielle Gern, a Swiss artist and calligrapher, created some logotypes for the typography. These were scanned and then redrawn in Illustrator to create vector images, enabling the logotype to be accurately scaled to any size. This is necessary when large-scale promotional material, such as posters, is required.

5 These images show work in progress before the final one was decided upon. A CD cover's dimensions are 4.7in x 4.7 in, but the files were created at 5.1in x 5.1 in, RBG at 300 dpi, with an extra 0.4 in allowed for the bleed. This meant there was a "safe area" that held no important information. The images were copied in the layers palette to create a master layer so it would be possible to go back to the original state if needed. As the reds in the image are very close to the borderline of being able to print in CMYK, the final Photoshop file was converted from RGB to CMYK with LinoColor software ready for repro.

adobe **photoshop**, adobe **illustrator**,

heidelberger druckmaschinen **linocolor**

designer tony stiles title the place of angels
photography david scheinmann calligraphy gabrielle gern
interview with the angel © 2001 instant karma

MAP ©1999 PROFESSOR M.A.R.BARKER • ARTWORK ©1999 PETER GIFFOR[D]

creating fantasy maps

bringing it all in

Fantasy art does not have to feature a scene or contain characters. Almost every fantasy novel, from *The Hobbit* onwards, has included some sort of map or chart that helps to place the reader more fully in the author's imagined world.

One such world is M. A. R. Barker's *Tékumel*. The artist Peter Gifford created a series of maps such as the one shown here, using photographic source material, Photoshop effects, and complex multilayering to produce an illustrated rather than a computer-generated look and capture some of *Tékumel*'s rich atmosphere.

adobe **photoshop**, adobe **illustrator**, alien skin software **eye candy**

artist peter gifford **title** tékumel: the world of the petal throne

2 In Photoshop, a scan is opened of a picture of a stone slab from one of the Hindu temples at Khajuraho in India. This gives an excellent basis for the required rich textural look Throughout the project, the colors and contrast of this texture are adjusted using the *Hue/Saturation* and *Levels* dialog boxes. The base layer is also given a "woven parchment" effect using a plug-in called, appropriately enough, "Weave," from the Alien Skin Software plug-in set Eye Candy. For areas of plains, desert, sea, forest, and swamp copies of the original texture—moved, scaled, and colored—are used.

1 Using a scan imported into Adobe Illustrator as a template, the *Pencil* tool is used with a Wacom pen and tablet to trace the landmasses in the existing maps. These shapes are filled with black and then copied and pasted into a new document in Adobe Photoshop. The road and river systems are also traced in Illustrator for later use.

3 The landmass shape previously pasted from Illustrator is used as a "mask" for the texture. The shape layer is moved under the texture layer, the latter selected and the command *Layer > Group with Previous* selected—or option-click (Mac)/alt-click (Windows) on the line between the layers. The texture is masked by the shape. This is a very flexible technique that you can use throughout a project like this, creating shape masks for the areas of terrain and grouping them with their respective textures. You can easily move and scale the texture without affecting the mask within which it is placed, and the mask itself can be manipulated to change the way the texture becomes part of the image.

4 Here is an example of mask manipulation. To make all the shapes more textural and their edges less defined, load the mask shape as a selection, run the *Select > Modify > Border* command to select an area around the shape's border, blur the edges of this selection using *Select > Feather*, then use *Blur* and *Noise* on this area to break up and blend the edge of the shape and make it more interesting. For the forest terrain, layers of *Noise* can be added to the texture and the *Filters > Noise > Median* filter applied to adjust the mask shape. The mountains benefit from the application of the *Emboss* filter to add dimension to the mask.

5 In Photoshop, layers are used to build up the various parts of the map. Careful organization of layers prevents confusion later on. Layers often have drop shadows applied to them to add depth to the image. Here you can also see the map key graphic, created with the same techniques. The two small "ledges" are once again sourced from scans of photos taken in India. Type is created in Photoshop—in the case of the script, using special fonts developed for *Tékumel*. Rivers and roads previously traced in Illustrator are copied and pasted into the Photoshop file, colored where necessary and drop shadows added. The last step is to add the names of cities and places.

Over the next 34 pages, we have brought you a showcase of some of the best examples of digital fantasy art from around the world. The scope, subject, style, and methodology of fantasy artists is very broad indeed, and this section provides a snapshot of some of the work presently under way.

As software becomes more sophisticated, and storage and memory more efficient, we can expect to see ever more fantastic yet, at the same time, more realistically rendered, scenes. The future of computer-generated fantasy illustration looks set to go from strength to strength...

the gallery

discreet 3ds max,
adobe Photoshop

artist frank vitale **title** wolf city

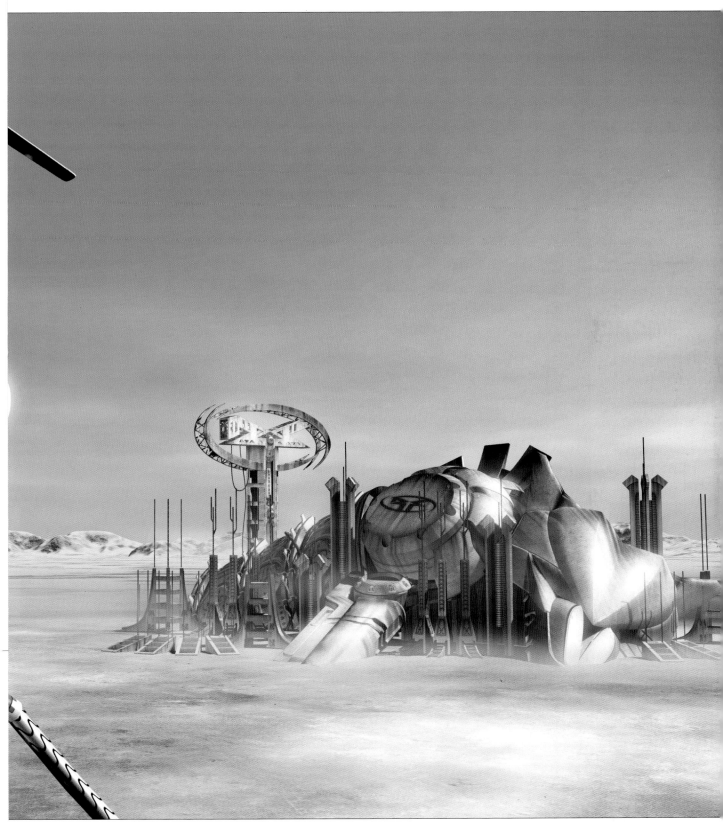

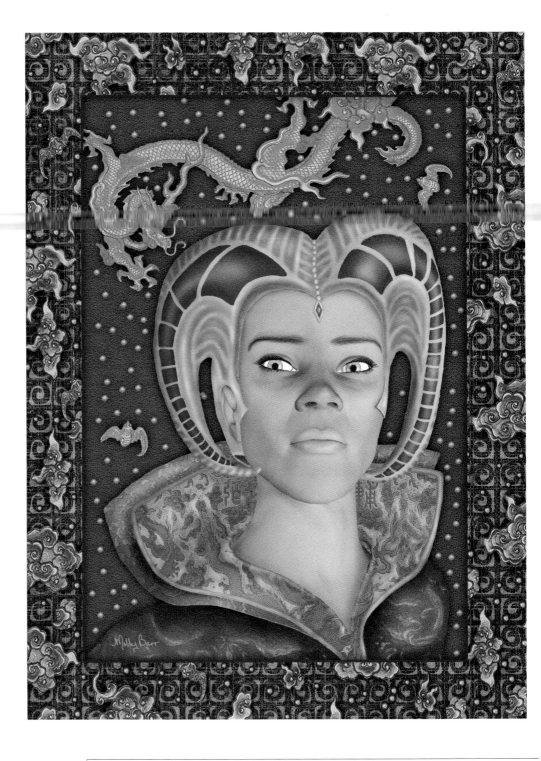

curious labs **poser** adobe **photoshop**

artist molly barr **title** the dragonmaster

adobe photoshop

artist kristen perry **title** flikk, the egg thief

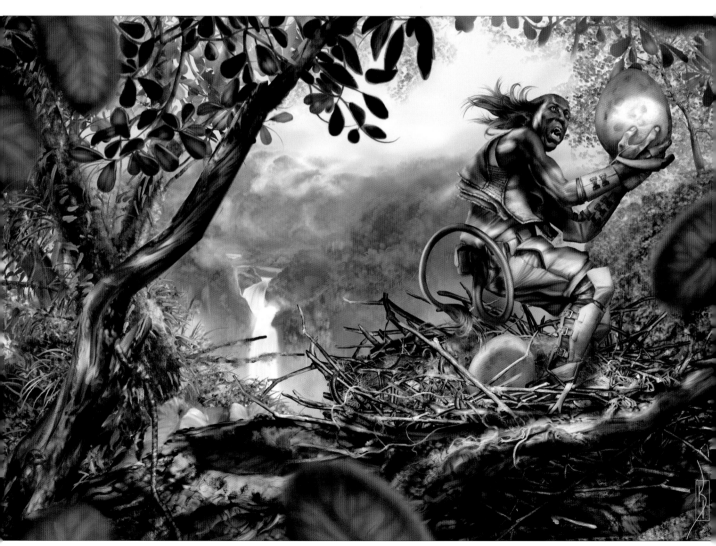

discreet **3ds max**

artist peter syomka **titlє** sky tower

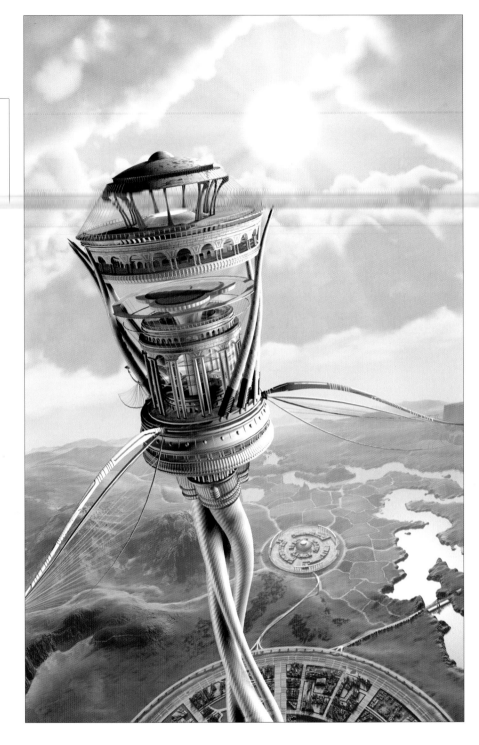

maxon **cinema 4D,**
adobe **photoshop**

artist frank vitale **title** capsule

the gallery

discreet **3ds max,** rhinoceros **rhino3d**

artist peter syomka **title** industrial portrait

adobe **photoshop**

artist martin mckenna **title** hoopsta

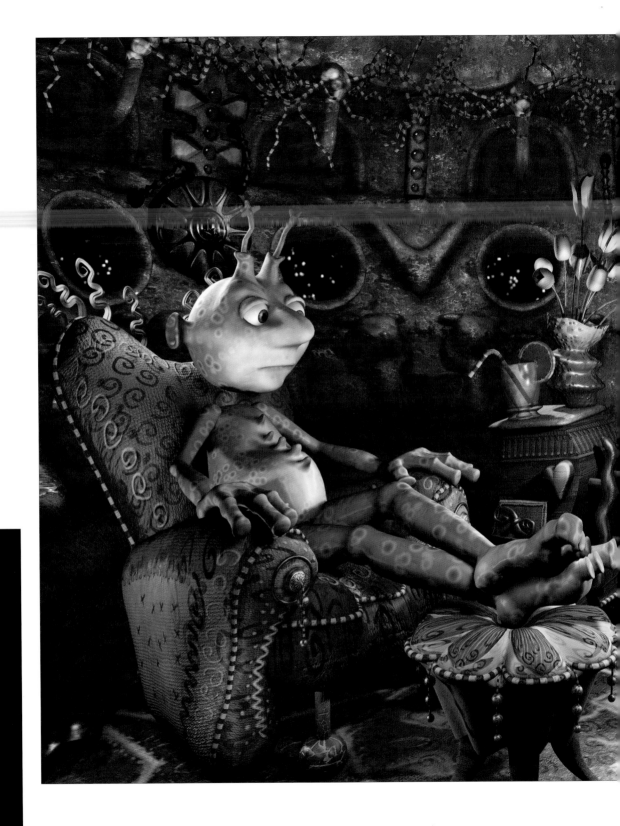

discreet 3ds max,
izware nendo,
adobe photoshop

artist eni oken **title** resident alien (left) funhouse (below)

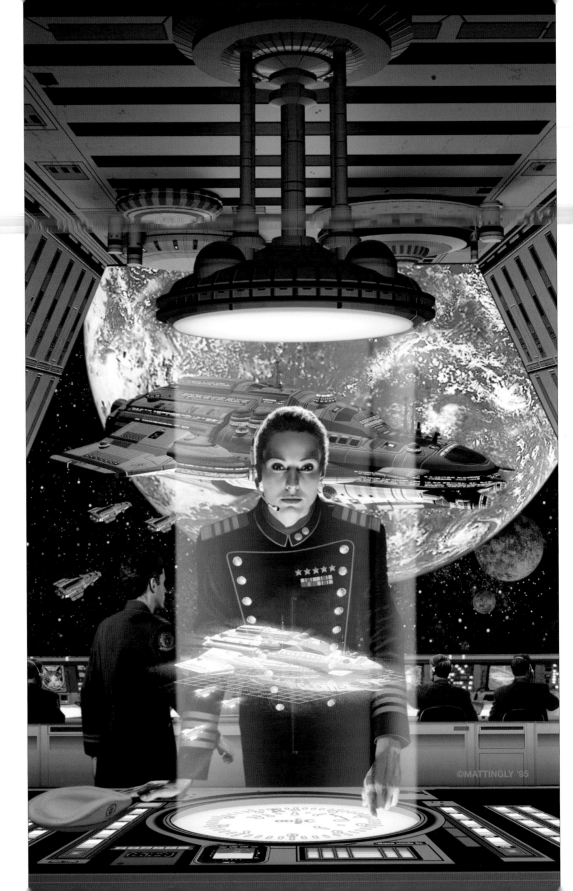

the gallery

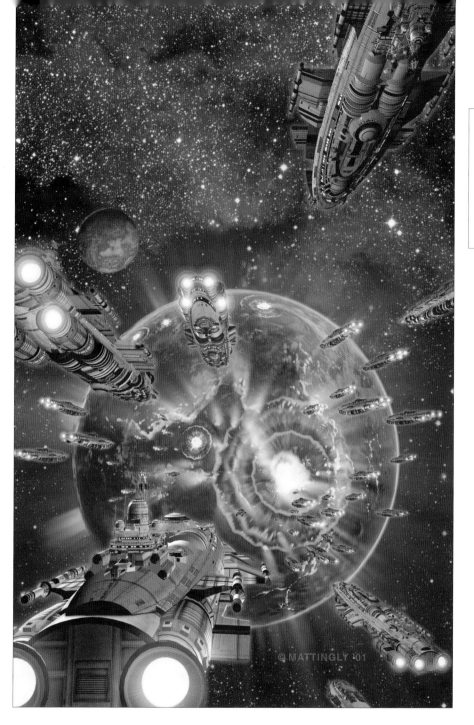

discreet **3ds max,**
adobe **photoshop**

artist david mattingly
title shiva option

discreet **3ds max,**
adobe **photoshop**

artist david mattingly **title** honor among enemies

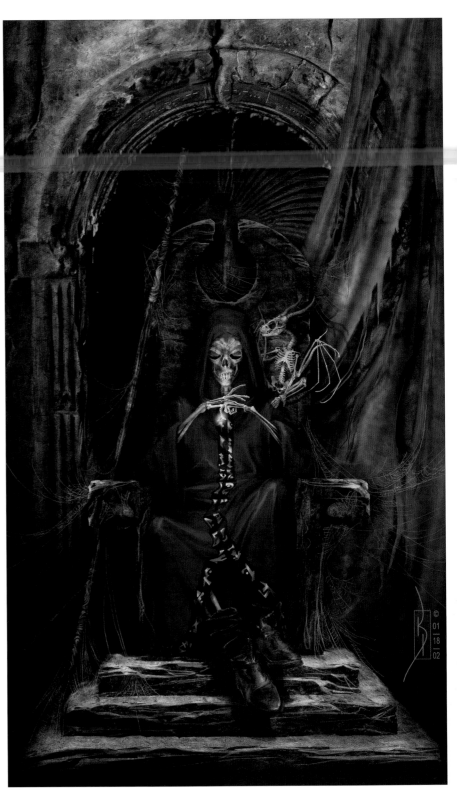

alias/wavefront **maya**

artist steven stahlberg **title** flamethrower

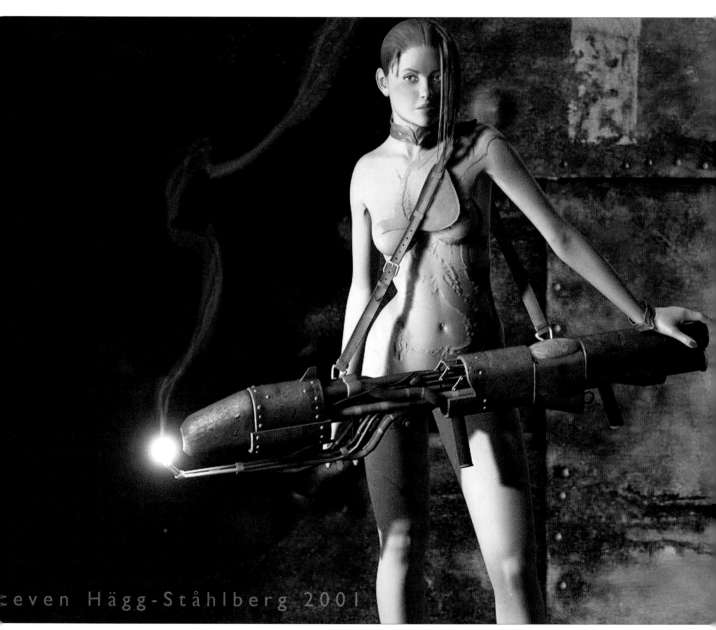

ceven Hägg-Ståhlberg 2001

the gallery

RANDIS ALBION
8::M 2001

curios labs **POSEr,**
corel **bryce,**
adobe **photoshop**
& illustrator

artist david ho
title id, ego, superego

adobe **photoshop**

artist randis albion **title** memento mori

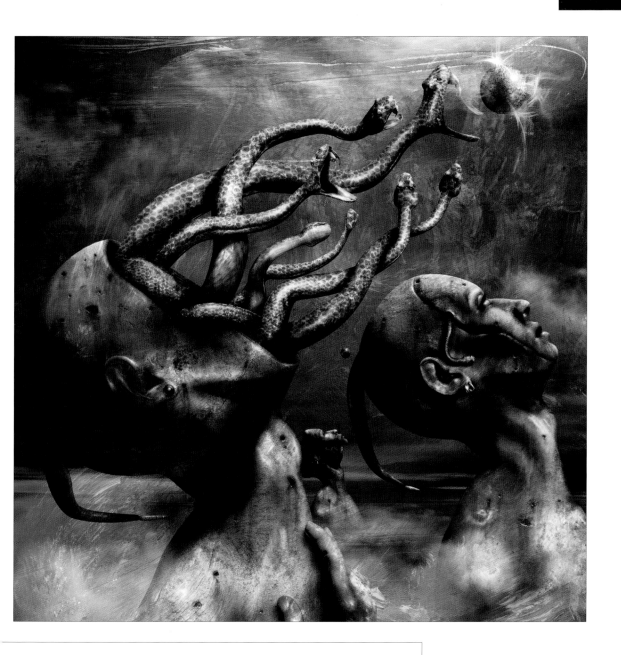

curios labs POSEr, corel bryce,
adobe photoshop & illustrator

artist david ho
title contemplation (left) leviathan (above)

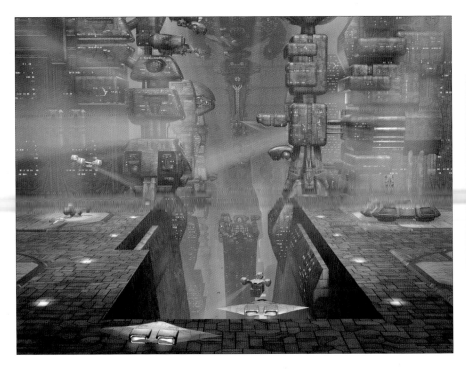

discreet 3ds max,
corel painter

artist steffen sommer
title alien city (above) container transporter

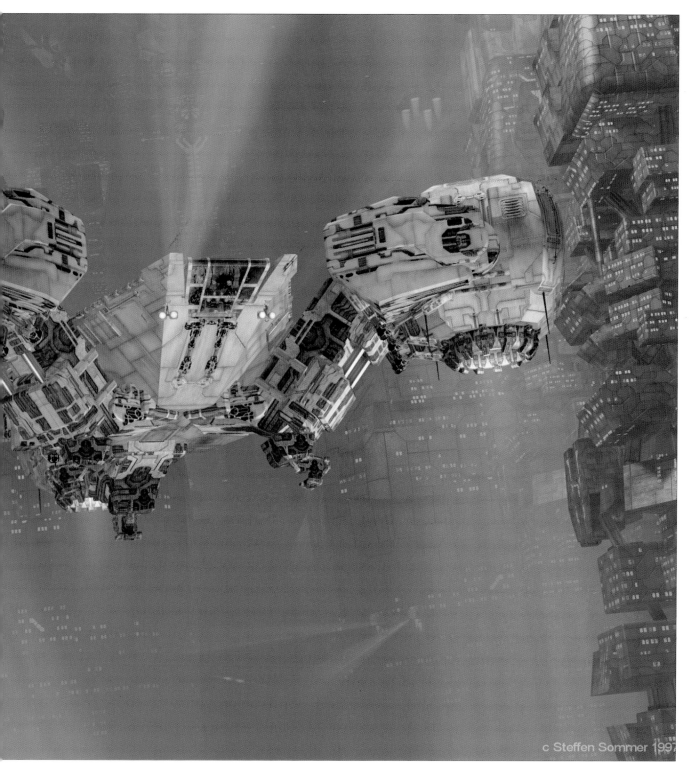

c Steffen Sommer 1997

maxon cinema 4D,
adobe photoshop

artist frank vitale
title scorpion (left) wolf (below)

adobe photoshop

artist roberto campus **title** bronze

discreet **3ds max,**
right hemisphere **deep paint 3d**

artist anatoliy meymuhin **title** into the ball of chrystal

newtek
lightwave 3d

artist dmitry savinoff
title stormbringer

curious labs poser,
adobe photoshop, e-on vue d'espirit

artist michael loh **title** dragon throne

147

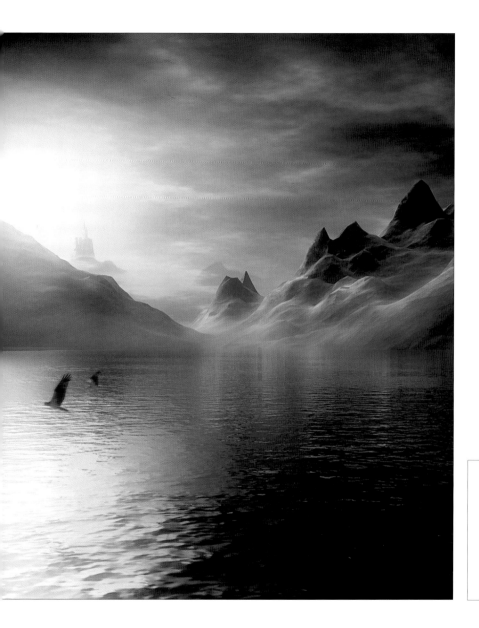

newtek
lightwave 3d

artist dmitry savinoff
title mountain lake

newtek
lightwave 3d

artist dmitry savinoff **title** the castle

newtek
lightwave 3d

artist dmitry savinoff
title fairy forest

16-bit color

A facility in image-editing applications that allows you to work on images in 16-bit-per-channel mode, rather than eight, resulting in finer control over color, but larger file sizes. An RGB image would total 48 bits (16 x 3) and a CMYK image 64 bits (16 x 4).

24-bit color

The allocation of 24 bits of memory to each pixel, giving a screen display of 16.7 million colors (a row of 24 bits can be written in 16.7 million different combinations of 1s and 0s). Twenty-four bits are required for CMYK separations (eight bits for each).

additive colors

Describes the light-based primary colors of red (R), green (G), and blue (B) which, when added together, create white. RGB is used to form every color for display monitors and image reproduction.

alpha channel

Pixel channel used to store data such as mask or transparency information. Appears as a separate grayscale channel, which accompanies any image file and determines which parts of the final image are affected.

anchor

Adjustable points, such as curve or corner points, added when changes of direction are introduced into a path.

bitmap

"Map" describing the location and binary state (on or off) of "bits," which defines a complete collection of pixels or dots that comprise an image. Unlike vector graphics, bitmapped images are not mathematically defined.

blend(ing)

A merging of two or more colors, forming a gradual transition from one to the other. The quality of the blend is limited by the number of shades of a single color that can be reproduced without visible banding.

BMP

Windows file format for bitmapped or pixel-based images.

bump map

Surface material that adds "bump" or depth detail to the surface of a model without actually affecting its geometry.

burn

A technique originating in photography which when applied darkens up parts of an image. The burn tool is found in many 2D image-editing applications.

cast

When the color balance of a scan is wrong; for example, if the image appears too blue or red.

chroma

The intensity, or purity, of a color; thus its degree of saturation.

clipping

Limiting an image or piece of art to within the bounds of a particular area.

color gamut / color space

The full range of colors achievable by any single device in the reproduction chain. While the color spectrum contains many millions of colors, not all of them are achievable by all devices, such as a four-color commercial press.

color picker

A color model displayed on a computer monitor, which may be specific to either an application, or to your operating system.

color temperature

The temperature—measured in degree Kelvin—to which a black object would have to be heated to produce a specific color of light.

CMYK (Cyan, Magenta, Yellow, and Key Plate)

The four-color printing process based on the subtractive color model. Black is represented by the letter K, which stands for key plate. In theory, cyan, magenta, and yellow when combined form black, but in the printing process this is difficult to achieve and expensive, hence the additional use of the black ink.

Control Vertices (CVs)

Handles that pull a curve into a more fluid, organic shape. CVs do not lie on the curve itself, but "float" above the surface.

curves

Adjustment parameter in image-editing applications that allows precise control of the entire tonal range of an image.

density range

The maximum range of tones of an image, measured as the difference between the darkest and lightest tones.

dodge

A technique originating in photography which when applied lightens up parts of an image. The dodge tool is found in many 2D image-editing applications.

extrusion

The method of creating a 3D object from a 2D path.

hierarchy

Tree structure listing objects in a scene or materials on a object, in order to display the logical relationships between them.

layers

Used in many software applications, layers allow you to work on one element of an image without disturbing the others.

levels

Adjustment parameter in image-editing applications that allows the user to correct the tonal range and color balance of an image by adjusting intensity levels of the image's shadows, midtones, and highlights.

loft(ing)

Lofting is where a surface is applied to a series of profile curves that define a frame.

lossless compression

Methods of file compression in which little or no data is lost.

lossy compression

File compression where data is irretrievably lost. JPEG is a lossy format.

metaballs

Used in 3D modeling, these are spheres that blend into each other.

NURBS

Non-Uniform Rational B-Splines. A technique that is used to interactively model 3D curves and surfaces.

Omni light

Illumination source that points light in
all directions.

parent

An object that is linked to another (known
as a "child") in a modeling hierarchy. When
the parent moves, the child object moves
with it.

perspective

A technique of rendering 3D objects on a 2D
plane, by giving the impression of an object's
relative position and size when viewed from
a particular point.

pixel

A contraction of "picture element." The
smallest component of any digitally
generated image, such as a single dot of
light on a computer screen. In its simplest
form, one pixel corresponds to a single bit:
0=off, or white; 1=on, or black. In color or
grayscale images, one pixel may correspond
to up to 24 bits.

pixellation

Where an image appears blocky and the
pixels are visible.

polygon

A number of connected points that together
create a shape or face. Polygonal meshes are
created from joining the faces together.
These form geometric shapes.

primitives

Simple geometrical objects in 3D applications
such as spheres, cubes, and cylinders, which
are combined together or deformed to create
more complex shapes.

PSD

Image format for files created using
Adobe Photoshop.

rasterize

To electronically convert a vector graphics
image into a bitmapped image.

ray tracing

Rendering procedure that sends out
hypothetical rays of light originating from the
objects in a scene in order to determine the
appearance of each pixel in the final image.

reflection map

Surface material that determines what is
reflected in an object's surface.

render / rendering

The application of textures and lighting, which
together transform a collection of objects into
a realistic scene. All the data in the 3D scene—
the location and nature of all light sources,
locations and shape of all geometry, and also
the location and orientation of the camera
through which that scene is viewed—are
collected to create a fully realized 2D image.

revolve (tool)

This creates a surface from a profile curve
that revolves around a defined axis.

RGB (Red, Green, Blue)

The colors of the additive color model, used
on monitors and in Web graphics.

shaders

Shaders determine the appearance of an
object. These are layers of attributes that
make up how the surface of the model
reacts to light, color, reflectivity, appearance,
and so on.

smoothing

In drawing and 3D applications, the refinement of paths or polygons.

specular

The "highlight value" of a shiny object.

spotlight

Illumination in one specific direction, along a cone-shaped path.

subdivision surfaces

Geometric surface type used for modeling organic objects. Usually built from a refined polygonal mesh.

texture map

A 2D image (such as a JPG image) used as a shader. Texture maps are applied to the surface of a 3D object in order to give it extra detail, such as scratches and patterns. They can be created inside the 3D application using procedural methods or imported as 2D bitmapped images (file textures) from a digital photo.

TIFF or TIF

Tagged Image File Format. A standard and popular graphics format used for scanned, high-resolution bitmapped images and color separations.

translation

Manipulation of the position of an object.

transparency map

Surface material that determines what is reflected in a transparent object's surface.

UV co-ordinates

The vertex co-ordinates of a model that define the surface parameters of an object and therefore let artists accurately place parts of an image onto the correct place. (*See* texture map)

UV mapping

A way to texture map a 3D polygonal model using the UV co-ordinates.

vector graphics

Images made up of mathematically defined shapes, or complex paths built out of mathematically defined curves. As a result, they can be resized or displayed at any resolution without loss of quality, but lack the tonal subtlety of bitmaps.

vertex

A control point on a path. Often shortened to "vert."

VRML

Virtual Reality Modeling Language. An HTML-type programming language designed to create 3D scenes (virtual worlds).

wireframe

A three-dimensional object viewed as a mesh with no "surface" or texture applied to it (the object has yet to be rendered).

Details of major software featured in this book

Adobe Photoshop (www.adobe.com)

Maya (www.aliaswavefront.com)

Corel Bryce (www.corel.com)

Curious Labs Poser (www.curiouslabs.com)

discreet 3ds max (www.discreet.com)

e-on Vue d'Esprit (www.e-onsoftware.com)

Newtek Lightwave (www.newtek.com)

Pixologic Zbrush (www.pixologic.com)

procreate Painter (www.procreate.com)

Other software

There are many other high-quality painting and modeling software applications. The following is just a sample.

AnimaTek World Builder by Digital Element (www.digi-element.com)

This is a traditional-style (four-window) 3D package for landscape generation. Powerful features include the ability to extrapolate terrain from simple lines sketched above ground plane. It integrates with discreet 3ds max via a plug-in, and supports Poser figure import.

BodyPaint 3D by Maxon software (www.maxon.com)

With this painting tool you can paint and draw directly onto 3D objects in real time. It also helps create detailed textures and can paint in real time onto a ray-traced image in 3D.

Carrara by Eovia (www.eovia.com)

Carrara Studio is the successor to Ray Dream Studio and Infini-D, two highly popular 3D graphics applications for the Macintosh and Windows. Carrara Studio is an extensible solution for modeling, animation, rendering, and special effects. It features spline and vertex-based modeling, a particle system, volumetric effects, and a shader tree material editor, and has an intuitive "room"-based architecture. It also enables full real-time scene manipulation and high-quality 3D rendering and ships with Eovia's NURBS modeling package, Amani 3D.

Expression by Creature House (www.creaturehouse.com)

This is a vector-based paint package that also offers fractal bitmap effects. It features natural media effects, live transparency, blending modes, object warping, and variable brush stroke width and opacity. It supports Photoshop filters and file export and also supports the use of a pressure-sensitive graphics tablet.

Nendo by Izware (www.izware.com)

Nendo is a quick and easy 3D modeling and painting tool. Streamlined for speed, it has a "floater" free interface and context-sensitive menus for reduced clutter on the desktop and allows users to model in a "digital clay" environment, based on traditional sculpting methods. Its interactive 3D painting tools include brush options such as size, opacity, and softness and an expandable color picker.

Paintshop Pro by JASC (www.jasc.com)

This highly popular and affordable image-editor on the Windows platform features extensible brush architecture called Picture Tubes—similar to the "image hose" in Corel PhotoPaint and Photoshop—as well as layers, a visual browser, general photo-editing tools, and special effects.

Photoshop Elements by Adobe

(www.adobe.com)

This cut-down version of Photoshop features most of the parent applications tools, while *Levels*, *Hue*, *Saturation*, *Invert*, *Brightness* and *Contrast*, are all included as *Adjustment Layers*.

Rhino by Robert McNeel & Associates

(www.rhino3d.com)

A Windows-only modeling tool that creates, edits, analyzes, and translates NURBS curves, surfaces, and solids, Rhino also supports polygon meshes—and there are no limits on complexity, degree, or size.

Softimage XSI by Softimage

(www.softimage.com)

An advanced high-end 3D modeling, rendering, and animation package featuring excellent polygon and NURBS modeling tools, Softimage also features fully integrated Subdivision Surfaces, interactive rendering, and global illumination. Mental Image's mental ray 3.0, integrated into XSI, provides superior ray tracing and the package also features the Render Tree, a graphical Shader network, advanced texturing tools, and a Hair/Fur simulation system. Softimage also produces Softimage 3D for modeling and animation.

trueSpace by Caligari (www.caligari.com)

This 3D modeling and rendering tool offers advanced capabilities, such as hybrid radiosity rendering and a direct-manipulation user interface. trueSpace provides real-time feedback on all operations and offers real-time display of bump maps, multi-textures, procedural textures, and environment mapping, as well as hardware accelerated lighting and geometry transforms.

Universe by Electric Image

(www.electricimage.com)

This cross-platform modeler and rendering software has an easy-to-use interface, enabling users to work with solid objects, NURBS, or UBER-NURBS (subdivision surfaces) in the same environment. A high-quality, photo-realistic ray tracing and scanline rendering system called Camera is seamlessly integrated within the Universe package.

Online sources of interest and further information

The sites listed below are merely useful examples of the many resources to be found on the Web. Many others exist and new sites and communities continue to appear.

Online galleries and communities

Elfwood (www.elfwood.com)

Huge not-for-profit site. Home to the online galleries of over 1,500 artists

Digitalart.org (www.digitalart.org)

Gallery of over 4,000 works of computer generated art

3D Artists

(www.raph.com/3dartists/artgallery)

Gallery site with large number of artists

The Association of Science Fiction and Fantasy Artists (www.asfa-art.org)

US-based not-for-profit community and gallery site

Sites for discussion and information about 3D software and related issues as well as commercial services

3D Links (www.3dlinks.com)

3D Café (www.3dcafe.com)

3D Total (www.3dtotal.com)

index

Achilleos, Chris 7
Albion, Randis 136
Alias/Wavefront 10, 11, 40–1, 46–7, 48–9, 54–5, 62–3, 76–7, 135
Alien City 140
Alien Skin Software 42, 116–17
alien worlds 104–7
Alpha 26 12–13
alternative image editors 24–5
Animatek 108–11
Amulets III 4
Apple 10
Aqua pack 42
Argon 100–1
Arkayne 134
ATI 11
Atlantis Calling 16–17
Autumn Flirts with Winter 32–3

Balazs-Ward-Kiss 7, 38–9, 78–9
Barker, M. A. R. 116
Barr, Molly 102–3, 108–11
Blackfeet 42
BladePro 42
blbarret 60–1
branches 66–7
Bronze 144
Bryce 16, 32–3, 88–91, 96, 112–13, 137, 138–9

Campus, Roberto 72–3, 144
Canvas 14
Capsule 125
Cassini Space Probe 84–5
Castle, The 148
Castle Heights 122
Cebas 104–7
Centeno, Jhoneil 50–1
Cinema 4D 36–7, 125, 142–3
Cinematte 42
Clouds 98–9
commercial free objects 12–13
Communicator 111
Container Transporter 140–1
Contemplation 138
Corel 11, 14–15, 16–17, 24–5, 32–3, 42, 52–3, 80–1, 88–91, 104–7, 112–13, 137, 138–9, 140–1
CorelDraw 14, 42
Corrosive Marine 30–1
creating a Leaf 64–5
creating Branches and Plants 66–7
creating fantasy maps 116–17
creating hair 56–7
creating landscapes in Bryce 88–91
creating landscapes in Lightwave 92–3

creating realistic skin in 3D 48–9
creating textures 50–1
Curious Labs 12–13, 27, 28–9, 60–1, 68–9, 70–1, 108–11, 112–13, 120–1, 137, 138–9, 146

Darkling Simulations 47, 92–3, 94–5
DarkTree 47, 92–3, 94–5
Dawn Camp 123
Daz Productions 12, 29, 60–1, 68–9, 70–1
Dean, Roger 7
Deep One 24–5
Deep Paint 3D 24, 145
Defocus Dei 42
Demon (Soul Eater) 72–3
demons 72–5
Deneba 14
Digimation 42
Digital Dominion 42
Dirty Up 42
Discreet 7, 38–9, 48–9, 64–5, 66–7, 72–3, 78–9, 84–5, 96–7, 100–1, 104–7, 108–11, 118–19, 120–1, 124, 126–7, 128, 130–1, 132–3, 140–1, 145
Donald, Mark 76–7
Dosch Design 12, 42
Dragon Model 60–1
Dragon Quest 27, 60–1
Dragon Throne 146
dragons 78–81
Dragon's Keep 92–3
Druid 42
Druid, The 52–3
Duri, Daniele 36–7

E-on Software 10, 28–9, 34–5, 60–1, 146
Elsa 11
Encounter 34–5
Eye Candy 42, 116–17

Fairy Forest 150–1
fantasy creatures 70–81
fantasy people 68–9
Flamethrower 135
Flaming Pear 42
Foss, Chris 7
Frank'n'Fhurter 76–7
Freehand 14
Friendly Relations 38–9
Funhouse 131
Future Cityscape 126–7
Future of War, The 86–7

Gallery 118–51
Gate Keeper 96–7

Gern, Gabrielle 114–15
Ghostland 114–15
Gifford, Peter 116–17
Gilliland, Ken 28–9, 112–13
GIMP (Graphic/GNU Image Manipulation Program) 24
Gladiator Girl 20–1
Glitterato 42
Goodall, Medwyn 92–3
Guardian 45

Hall of Beginnings 94–5
hardware 10–11
Hawkriders, The 28–9
Haywood, James 20–1
Heidelberger Druckmaschinen 114–15
Heroes Leave 8–9
Ho, David 86–7, 137, 138–9
Honor Among Enemies 132
Hoopsta 129
Howard, Robert E. 7
Howell, Shannon 34–5

Id, Ego, Superego 137
Illustrator 14, 15, 114–15, 116–17, 137, 138–9
Industrial Portrait 128
inorganic objects 62–3
Interview with the Angel 114–15
Into the Ball of Chrystal 145
Irix 10, 40

Jhenna, Freelance Cop 18–19
Jones, Peter 7
Judith 36–7
Juta, Jason 24–5

Kai's Power Tools (KPT) 42
Kendall, Jason 12–13
King, The 22–3
Kluyskens, Tom 49
Knight Model 60–1
KPT Effects 42, 43

landscapes of the future 100–1
Last Son of Krypton 120–1
Leapfrog 43
leaves 64–5
Leviathan 139
lighting fantasy scenes 58–61
Lightwave 3D 24, 36–7, 42, 92–3, 94–5, 122–3, 147, 148–9, 150–1
LinoColor 114–15
Linux 10, 40
Little Village Far, Far Away 104–7
Loh, Michael 27, 60–1, 146
Lunar Cell 42

Mac OS X 10, 24, 34
Macintosh 10, 16, 40
McKenna, Martin 22–3, 44–5, 129
McKie, Angus 7
Macromedia 14
Mattingley, David 126–7, 132–3
Maxon 36–7, 125, 142–3
Maya 10, 11, 24, 36, 40–1, 46–7,
 48–9, 54–5, 62–3, 76–7, 135
Memento Mori 136
Meymuhin, Anatoliy 145
mice 11
'Michael' model 12, 70–1
Microsoft 10
Midnite Sun 102–3
modeling 26–7
modeling heads and faces 54–5
modems 11
monitors 11
monsters 76–7
Moorcock, Michael 7
Mountain Lake 149
Murphy, Martin 32–3
Murray, Gabriel 68–9, 70–1, 120–1
Myles, Socar 98–9

NASA 12, 13, 84, 85
Nendo 104–7, 130–1
Newsbringer, The 50–1
NewTek 36–7, 92–3, 94–5, 147,
 148–9, 150–1
Nichimen 104–7, 130–1
nVidia 11

O'Connor, Tony 95
Oken, Eni 104–7, 130–1
Onyx Computing 92–3
OpenGL 11
organic objects 64–7

Painter 11, 14–15, 16–17, 33, 52–3,
 78, 80–1, 104–7, 112–13, 140–1
painting the sky 98–9
Pate, David 76–7
Pennington, Bruce 7
Perry, Kristen 18–19, 56–7, 134
PhotoPaint 15, 24–5
Photoshop 11, 12–13, 15, 16,
 18–19, 20–1, 22–3, 24, 31,
 36–7, 38, 39, 42, 44, 46–7, 48–9,
 50–1, 52–3, 56–7, 58–9, 60–1,
 64–5, 66–7, 68–9, 70–1, 72–3,
 76–7, 78–9, 80–1, 82–3, 92–3,
 94–5, 96, 97, 98–9, 104–7,
 108–11, 114–15, 116–17,
 118–19, 120–1, 125, 126–7,
 129, 130–1, 132–3, 134, 136–7,
 138–9, 142–3, 144, 146

Pixologic 30–1, 74–5, 82–3
Place of Angels, The 114–15
plug-ins and filters 42–3
Poser 12–13, 27, 28–9, 33,
 35, 60–1, 68–9, 70–1,
 108–11, 112–13, 120–1,
 137, 138–9, 146
Potts, Jerry 96–7, 100–1
printers 11
professional image editing 14–17
Pyrocluster 104–7

Rackham, Arthur 7
Radiosity 77
Rain 121
Ray Dream Designer 33
Razareal the Painweaver 74–5
realistic flesh and skin in 2D 52–3
rendering 26–7
Renderosity 60–1
Resident Alien 130–1
Rhinoceros 128
Rhino3d 128
Right Hemisphere 24, 145
Rivendell 7
robots 82–3
Rogue Warrior 14–15

Sasquatch 92–3
Satori PhotoXL 24
Savinoff, Dmitry 8–9, 92–3, 94–5,
 122–3, 147, 148–9, 150–1
scanners 11
Scheinmann, David 114–15
Scorpion 142–3
Scott, Daniel 68–9, 70–1, 120–1
shaders and textures 46–7
Shag-Fur 43
Shag-Hair 43
Shiva Option 133
Silicon Graphics 10
Sisyphus Software 42
Skytower 124
Smiles 54–5
Smith, Adrian 40–1, 62–3
Smokin' 46–7
Softimage 24, 36
Solar Cell 42
Sommer, Steffen 7, 140–1
Southern, Glen 30–1, 74–5, 82–3
spacecraft 84–5
Stahlberg, Steven 46–7, 48–9,
 54–5, 135
Stiles, Tony 114–15
Stormbringer 147
Strongblade 60–1
Sub Attack 40–1
Summoner, The 112–13

Sun Microsystems 10
Sun Workstation 10
Sunny Delight 88–91
SuperBladePro 42
superheroes 68–9
Syomka, Peter 124, 128

Tablets 11
Teahouse, The 108–11
Techniques 48–9
Tékumel: The World of the Petal
 Throne 116–17
Teryn 56–7
3D Café on the Web 43
3D graphics software 26–7
3Dlabs 11
3ds max 7, 24, 38–9, 42, 43,
 48–9, 64–5, 66–7, 72–3,
 78–9, 84–5, 96–7, 100–1,
 104–7, 108–11, 118–19,
 120–1, 124, 126–7, 128,
 130–1, 132–3, 140–1, 145
Torpedo 62–3
torpedoes 62–3
Tree Professional 92–3

Ultimate 3D Links 12
undead, the 70–1

Vampire Goddess 58–9
Vernon, Ursula 16–17, 80–1
'Victoria 2' model 12, 68–9
visions of the future 82–5
Vitale, Frank 64–5, 66–7, 118–19,
 125, 142–3
Vue d'Esprit 10, 28–9, 34–5, 60–1,
 96, 146

Wankel, Robert 84–5
water effects 96–7
water, terrain, and skies 94–5
Weiss, André 58–9
When Dragons Fly 7, 78–9
White, Tim 7
Windows 10, 16, 24, 40
Windows XP 10
Wingless 80–1
Wojtowicz, Slawek 88–91
Wolf 143
Wolf City 118–19
Wonder Woman 68–9
World Builder Pro 108–11
Worley Labs 92–3

Yazijian, Michael 14–15, 52–3

Zborg, The 82–3
ZBrush 30–1, 74–5, 82–3

The Artists

The Publisher would like to thank the following artists for all their contributions in the creation of this title.

Randis Albion
weiss@massive.de
www.visual-god.com

Molly Barr
barr@dragontree.net
www.dragontree.net

Roberto Campus
bob@robertocampus.com
www.robertocampus.com

Jhoneil M. Centeno
jhoneil.mc@verizon.net
www.jhoneil.com

Mark Donald
mark@satch.worldonline.co.uk
www.satch.free-online.co.uk

Daniele Duri
d@denizen.it
www.denizen.it

Peter Gifford
head@universalhead.com
www.universalhead.com

Ken Gilliland
empken@empken.com
www.empken.com

James Haywood
james@jhaywood.com
www.jhaywood.com

David Ho
ho@davidho.com
www.davidho.com

Shannon Howell
showell@usit.net
www.shannonhowell.com

Jason Juta
juta@megatokyo.org
www.anzwers.org/
free/whispers

Jason Kendall
jason_kendall44@hotmail.com

Michael Loh
mwkloh@yahoo.com
www.geocities.com/mloh

David Mattingly
david@davidmattingly.com
www.davidmattingly.com

Martin McKenna
martin.mckenna@lineone.net
www.mckenna-world.fsnet
.co.uk

Anatoliy Meymuhin
aem3d@mail.ru
www.3dluvr.com/fantasy3d

Martin Murphy
m.murphy@attcanada.ca
www.members.attcanada.ca/
~m.murphy

Daniel Scott Gabriel Murray
kahuna@alpc.com
www.alpc.com

Socar Myles
rats@gorblimey.com
www.gorblimey.com

Eni Oken
eni@oken3d.com
www.oken3d.com

Kristen Perry
merekat@merekatcreations.com
www.merekatcreations.com

Jerry Potts
jpotts55@insightbb.com
www.geocities.com/SoHo/
Studios/1038

Dmitry Savinoff
deemon@savinoff.com
www.savinoff.com

Adrian Smith
AdyS@Core-Design.com

Steffen Sommer
steffsommer@gmx.net
www.raph.com/3dartists/
artgallery/ag-ap285.html

Glen Southern
glen@southerngfx.co.uk
www.southerngfx.co.uk

Steven Stahlberg
stahlber@yahoo.com
www.optidigit.com/stevens

Tony Stiles
info@v-on.com
www.v-on.com

Peter Syomka
syomka@i.com.ua
www.3dluvr.com/syomka

Ursula Vernon
setik@metalandmagic.com
www.metalandmagic.com/

Frank Vitale
vitalef@cox.net
www.vitalef.com

Robert Wankel
wankel@symbol.com
www.raph.com/3dartists/
artgallery/ag-ap151.html

Balazs-Ward-Kiss
ward@3dluvr.com
www.3dluvr.com/ward

Slawek Wojtowicz
sw6@georgetown.edu
www.slawcio.com

Michael Yazijian
yazstudios@hotmail.com
www.yazstudios.com